IMAGES
of America

THE DELAWARE & HUDSON CANAL AND THE GRAVITY RAILROAD

Fathers Of The Delaware & Hudson Canal

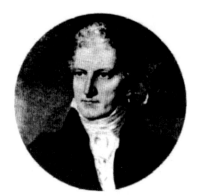

Philip Hone

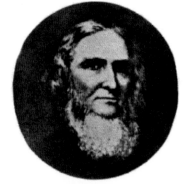

William Wurts

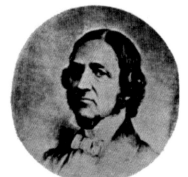

Maurice Wurts

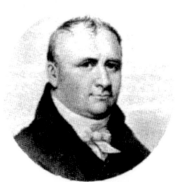

Benjamin Wright

These four gentlemen are recognized as the fathers of the Delaware and Hudson Canal. Philip Hone, a financier in the 1820s, was from New York City. He helped in organizing the company while serving as its first president. The Wurts brothers, William and Maurice, had a vision— selling anthracite coal to large markets in New York and beyond. Benjamin Wright, who had been the engineer of the Erie Canal, was hired to transform that dream into a reality. (Collection of the Minisink Valley Historical Society.)

IMAGES
of America

THE DELAWARE & HUDSON CANAL AND THE GRAVITY RAILROAD

Matthew M. Osterberg

ARCADIA

First printed in 2002.

Published by Arcadia Publishing,
an imprint of Tempus Publishing, Inc.
2A Cumberland Street
Charleston, SC 29401

Printed in Great Britain.

Library of Congress Catalog Card Number: 2002108390

For all general information contact Arcadia Publishing at:
Telephone 843-853-2070
Fax 843-853-0044
E-Mail sales@arcadiapublishing.com

For customer service and orders:
Toll-Free 1-888-313-2665

Visit us on the internet at http://www.arcadiapublishing.com

*This book is dedicated to all of the volunteers and government agencies
that are working to preserve the Delaware and Hudson Canal.*

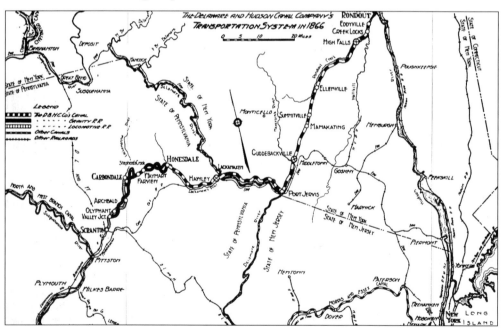

Shown here is a map of the Delaware and Hudson Canal and Gravity Railroad c. 1866. The coal was being moved 170 miles from Scranton, Pennsylvania, to Kingston, New York. With four other canals operating within a 100-mile radius of Honesdale, the popularity of canals by the mid-19th century was very evident. (Collection of the Minisink Valley Historical Society.)

CONTENTS

ACKNOWLEDGMENTS

There are a few people and organizations I would like to thank for helping me with the preparation of this book. I would like to begin first and foremost by thanking my wife, Carol. She typed many of the captions and kept me on course. I am deeply indebted to Peter Osborne for his guidance and knowledge, and for the writing of the introduction. I am very grateful to the Minisink Valley Historical Society for the use of their incredible photograph collection, which inspired me to write this book.

A special thank you to Dave and Cyndi Wood for allowing me to use a part of their vast collection of Ludolph Hensel, Edward Anthony, and Auchmoody stereo views and cabinet cards. These gentlemen documented the canal and railroad on film in the last half of the 19th century. I am also grateful to Robbie Smith and Robert Hartman for allowing the use of their photograph collections of the Delaware and Hudson Canal.

I would also like to thank Lizanne Samuelson, Marissa Luhrs, Beth Germann, Steve Szabara, Brian Lewis, Chris Thiele, and my children, Michael and Stephanie. These are the people who assisted in proofreading, editing, and computer imaging. Finally, I thank all of the writers who wrote extensively on the Delaware and Hudson Canal and are listed in the bibliography.

INTRODUCTION

In today's world, where it takes months of hearings with local planning boards just to get a new shed on one's property, it is hard to imagine how a corporation in the early 19th century, in a time span of only three years, could construct a 108-mile canal and a 50-mile gravity railroad. The builders faced some of the most difficult terrain imaginable, making their way through the base of mountains and along rivers and over ridge lines. Through sheer determination, the Delaware and Hudson Canal Company succeeded in constructing the region's largest project up to that date. One account from when the canal first opened in 1828 describes the viewer's amazement at seeing a horse pulling a boat along the towpath. He had never seen anything like it before. Curiously, he would live to see its closing in 1898 as well.

This is a story of great courage by the original creators—the Wurts brothers. They had the extraordinary vision and determination to think that they could ship coal from the Moosic Mountains of northeastern Pennsylvania to the metropolitan markets of New York—an unbelievable distance of more than 171 miles, stretching through more than two states. Through the determination of the Wurts family members and company stockholders, a dream came to pass. Other canal managers, the "holy trinity" of the canal engineering department— as the well-known canal historian Larry Lowenthal called them—were incredibly loyal, talented, and dedicated men. John B. Jervis, Russel F. Lord, and James Archbald all helped to build the canal and gravity railroad. Lord and Archbald would serve as chiefs of the canal and railroad divisions, respectively, for many years and were directly responsible for the successful and profitable running of the canal. Jervis would go on to bigger and more significant projects in the years to come.

At a recent symposium on the gravity railroad, nationally-known wire rope expert Donald Sayenga reflected that the history of technology is not taught in schools anymore. He is right. When one thinks of the canal and gravity railroad, it is not how it works that we are most interested in but rather the romantic and idyllic scenes that are shown in the photographs. However, technology is an important part of this story, and if one looks closely at the photographs, the evidence is incontrovertible. Without the surveyors and accurate surveying equipment, a perfectly level canal could not have been constructed, as the water would gravitate toward the low end. If locks or gravity planes had not been developed, the system could not have worked. Without the design of the suspension bridges by renowned engineer John Roebling, the canal could not have been carried over four different rivers. The cables carried the weight of the superstructure, water, and boats flawlessly until the closure of the

canal. Roebling's earlier invention of wire cable rope was used on the gravity railroad. It replaced the hemp rope and chains that had failed regularly with great cost to the company. The Delaware and Hudson Canal Company also introduced the first telegraph to its system and brought to America the first commercial steam locomotive. All of these inventions were instrumental in the construction of the gravity railroad. The inventions reflect a company that constantly tried to build more efficiently and more profitably. From a corporate point of view it is believed to have been the first corporation in American history to be capitalized at one million dollars and also the first to fire its chief executive. It was the first vertically integrated company. Even as the Civil War was being fought, the Delaware and Hudson Canal Company looked to the future and invested in a railway system that would someday succeed its canal system.

This is also a story about water. The company had more than 20 reservoirs and several feeder dams along the region's rivers, which provided it with a steady flow of water and crossed four major rivers. Every lock used 10,000 gallons of water when a boat was locked through. The company owned thousands of acres of ground for use as a timber reserve. This is also a story about people—those who owned and profited from it, designed and constructed it, and worked and floated along it. It is also a story of child labor, which was used without the restrictions that are now part of our nation's conscience. Finally, the emergence of the canal and gravity railroad reflects a time when we were not so concerned about our environment, as mines were opened and left when more productive veins were discovered. Raw sewage and by-products from other industries were dumped into the canal. The flows of rivers were altered and forests stripped of their lumber. In the end, this is an American story.

Our society is proud to be a part of this book, and we are pleased with the work of Matthew and Carol Osterberg. We are grateful for their hard work and for the donations of others that made this book possible. They have done an important job of preserving the history of the Delaware and Hudson Canal and Gravity Railroad. This is the first canal book dedicated just to the photographic history of the D & H. This book, however, represents something more than just a collection of photographs; it adds to the resurgence of interest in the canal and gravity railroad, as projects to preserve it have been happening all along the 171-mile route today. New trails, museums, guides, brochures, and web pages are being created that will someday form a heritage corridor. In the last 25 years, much has been done to preserve the history of the Delaware and Hudson. The momentum is growing for those of us who are preserving it in the form of the Delaware and Hudson Transportation Heritage Council. For more information about our society and the D & H, go to our web page at www.minisink.org.

—Peter Osborne
Executive Director
Minisink Valley Historical Society, Port Jervis, New York

One
THE GRAVITY RAILROAD

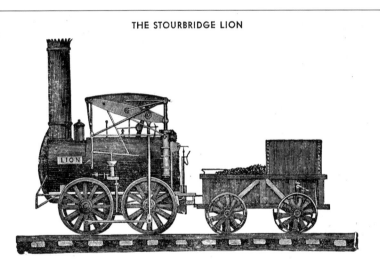

THE STOURBRIDGE LION

The First Locomotive to Turn a Wheel Upon a Railroad in America.

Place, Honesdale, Wayne County, Pa.; Date, August 8, 1829; Railroad, D. & H.

Engineer, Horatio Allen, who died at Montrose, N. J., Dec. 31, 1889, Aged 87 years and 7 months.

In 1829, the Delaware and Hudson Canal Company purchased four steam locomotives in England to be used on the gravity railroad. On August 8, 1829, one of them, the *Stourbridge Lion*, became the first commercial locomotive to run on a track in the western hemisphere. Delaware and Hudson Canal Company engineer Horatio Allen operated the engine on this summer day, thus transforming travel in the young country. These engines were to be used to move coal across the Moosic Mountains from Carbondale. Due to weight problems, they were scrapped and a gravity railroad was developed, first using water and horse power and, later, stationary steam engines. (Collection of the Minisink Valley Historical Society.)

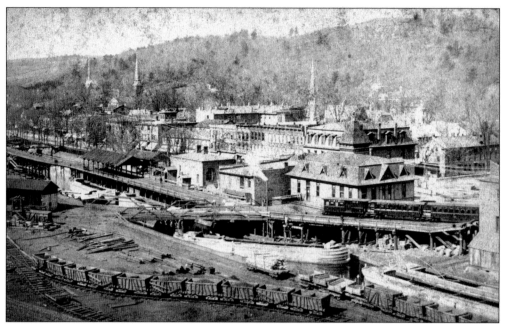

Shown here is a Hensel cabinet card of central Honesdale as seen from the coal piling docks *c.* 1880. It was here in 1826 that construction of the gravity railroad began under the direction of John B. Jervis. The original railroad ran from Honesdale to Carbondale for 17 miles and was completed in 1829. (Dave and Cyndi Wood.)

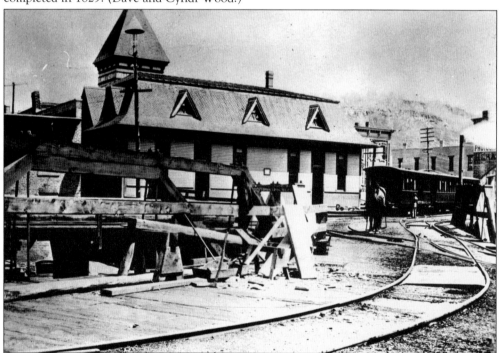

The Honesdale Gravity Railroad Station was built after passenger travel was added to the line in the 1870s. This *c.* 1880 photograph shows a horse-drawn train being pulled up to the first plane, bound for Carbondale. (Collection of the Minisink Valley Historical Society.)

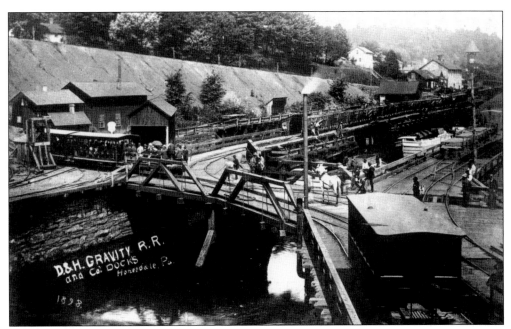

In this c. 1885 photograph, the town of Honesdale and its large mountains of coal are pictured. To the left are loaded coal cars preparing to be unloaded and canal boats preparing for the trip to the Hudson River. Prior to the canal, this area of Pennsylvania was mostly wilderness; with the coming of the canal that all changed, including the town's name. It was named after the first president of the canal company, Phillip Hone. It had been known earlier as Dyberry. (Collection of the Minisink Valley Historical Society.)

In Honesdale, a passenger train begins its trip up the plane toward Farview. In the upper right is the building that housed the stationary engine that supplied power for the uphill ascents. (Collection of the Minisink Valley Historical Society.)

11

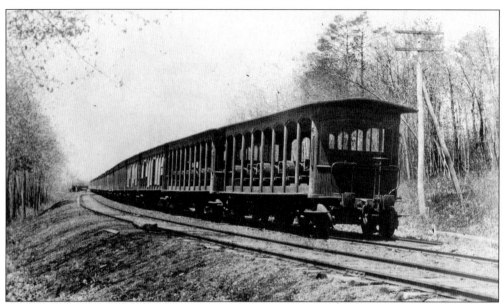

These open-air excursion cars were used by tourists. The ride on the gravity railroad provided passengers with clean air, free from any coal dust from the engines. One traveler described it as "free falling, a gentle ride." (Collection of the Minisink Valley Historical Society.)

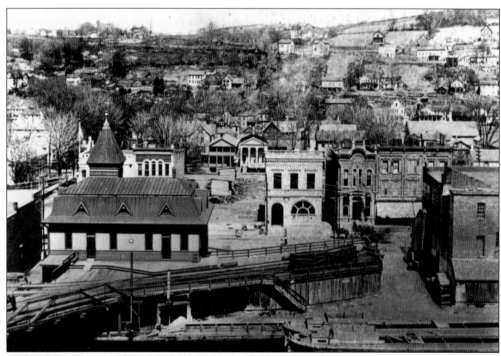

Shown here is a c. 1875 view of the Delaware and Hudson Gravity Station in Honesdale. The use of passenger trains from Carbondale to Honesdale continued for many years. These excursions were so popular that, by the 1890s, six passenger trains departed for Carbondale each day. (Collection of the Minisink Valley Historical Society.)

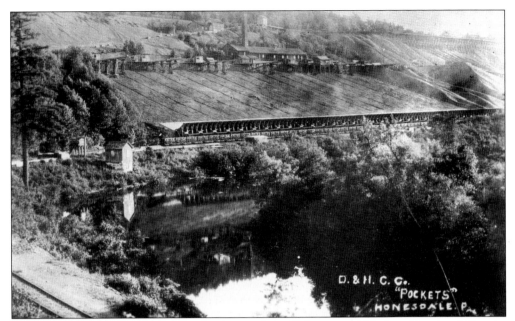

The entire Honesdale economy revolved around the Delaware and Hudson Canal and Gravity Railroad. This c. 1890s view shows the massive coal pockets that were located in Honesdale. (Collection of the Minisink Valley Historical Society.)

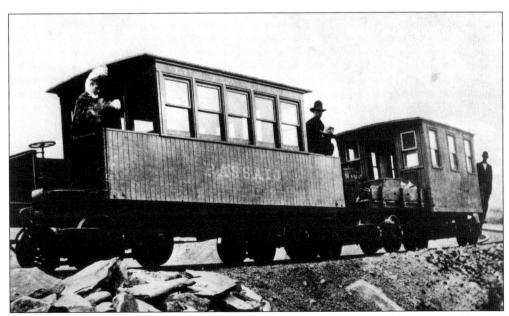

Private coaches also ran on the gravity railroad. Here, the *Passaic* stops on the curve of Shepards Crook just outside of Carbondale c. 1880. (Collection of the Minisink Valley Historical Society.)

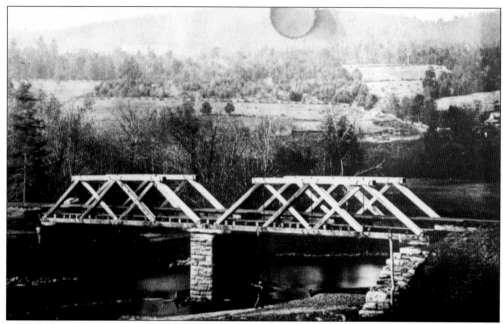

This bridge, built in 1847, was located on the long descending plane near Prompton. The original gravity railroad had eight planes and ascended 950 feet in the first four miles to reach the summit of the Moosic Mountains when it was completed in 1829. This photograph was taken in 1880. (Collection of the Minisink Valley Historical Society.)

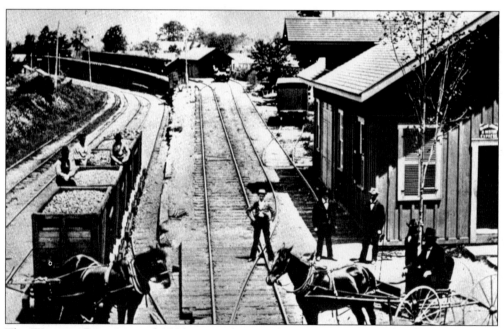

The Waymart Depot, c. mid-1880s, was where coal was stored and weighed, thus the name Waymart. In the 1850s, the railroad was expanded, and the number of planes increased between Carbondale and Waymart from five to eight. (Collection of the Minisink Valley Historical Society.)

The railroad was expanded and upgraded four times after its construction in 1828. In the 1880s, it was capable of moving more than four million tons of coal. In this 1880 Hensel view, a long line of loaded cars ascends Plane 12 in Waymart. These cars were pulled up the plane and then run by gravity to the foot of the next plane. Each of these cars held five tons of coal. (Dave and Cyndi Wood.)

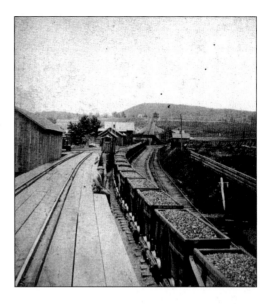

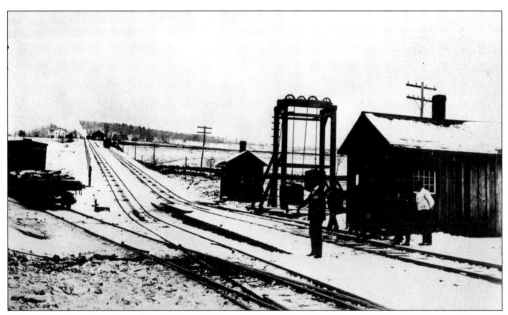

The original railroad ran from Honesdale to Carbondale. Seen here is Plane 12 descending and Plane 18 ascending in Waymart. Originally, there were three planes that descended into Honesdale. These were operated strictly by gravity; loaded cars descending drew empty cars back up the mountain, as they were all attached to the same chain. (Collection of the Minisink Valley Historical Society.)

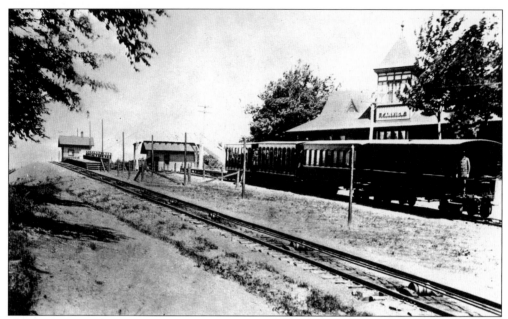

The Farview Station was the summertime destination for many tourists. This popular station sat at one of the highest elevations on the gravity railroad. In this *c.* 1890s photograph are two closed coaches and two open-air cars waiting on the side while the passengers finish their picnic lunch. (Collection of the Minisink Valley Historical Society.)

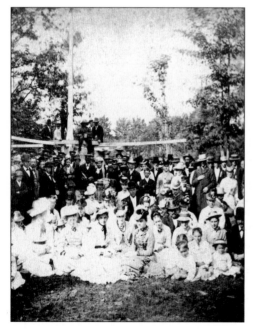

These picnickers pose for photographer Ludolph Hensel while enjoying a clear summer day at Waymart in the 1880s. These trips were planned months in advance and were attended by hundreds of tourists. (Dave and Cyndi Wood.)

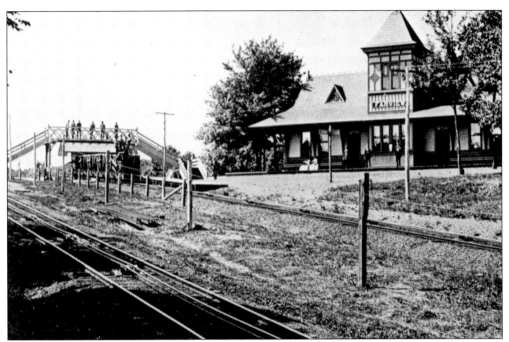

Farview Station was a favorite getaway for Sunday school groups *c.* 1880s. They would enjoy a picnic lunch and later hike to an observatory on top of the Moosic Mountains that held breathtaking views of the surrounding valleys. (Collection of the Minisink Valley Historical Society.)

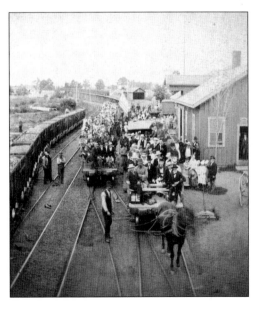

This *c.* 1880s photograph shows the very busy Waymart Station. Large crowds would spend Sundays and holidays enjoying the grand views and the exhilarating ride on the gravity railroad. (Dave and Cyndi Wood.)

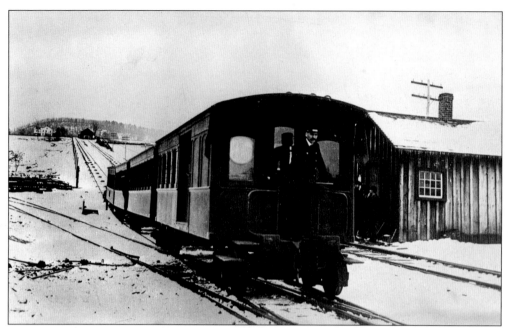

The passenger trains on the Delaware and Hudson were operated by three men. The crew consisted of a conductor and two brakemen—one at the head of the train and one at the rear. They would operate the brake and signal when approaching the stations. This *c.* 1890s photograph shows the head brakeman ascending his train atop the Moosic Mountains. The last train to run the entire gravity railroad arrived in Honesdale on January 21, 1899. (Collection of the Minisink Valley Historical Society.)

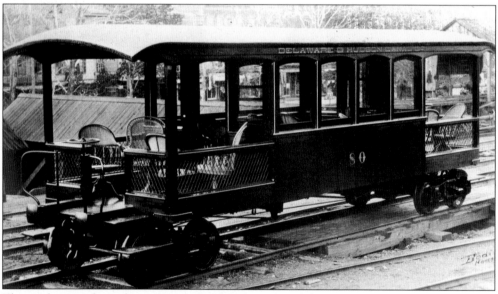

This parlor car along the gravity railroad only operated during the summer months. It was equipped with comfortable swivel seats where enthusiastic travelers enjoyed conversing with their fellow riders while taking in the beautiful views. (Collection of the Minisink Valley Historical Society.)

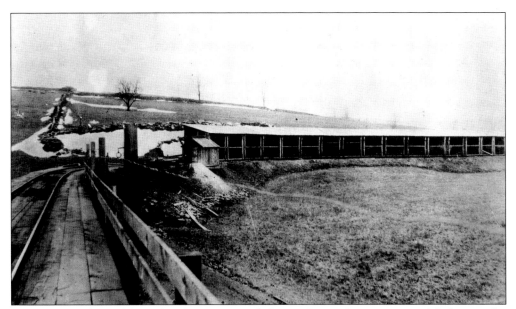

The passenger line of the railroad was operated all year. Due to heavy snow and drifting in the winter months, large snow sheds were constructed. This one, pictured in 1890, was near the Farview and the Moosic Summit. (Collection of the Minisink Valley Historical Society.)

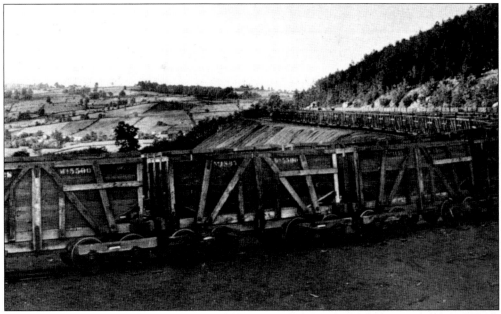

Prior to the railroad, coal was transported by wagon from Carbondale by way of the Milford-Owego Turnpike, which was extremely slow and costly. With the completion of the railroad, coal became more easily transported. This long row of 22 cars, each carrying five tons, shows the magnitude of coal brought out of the mines on a continual basis. This is near Farview c. 1880. (Collection of the Minisink Valley Historical Society.)

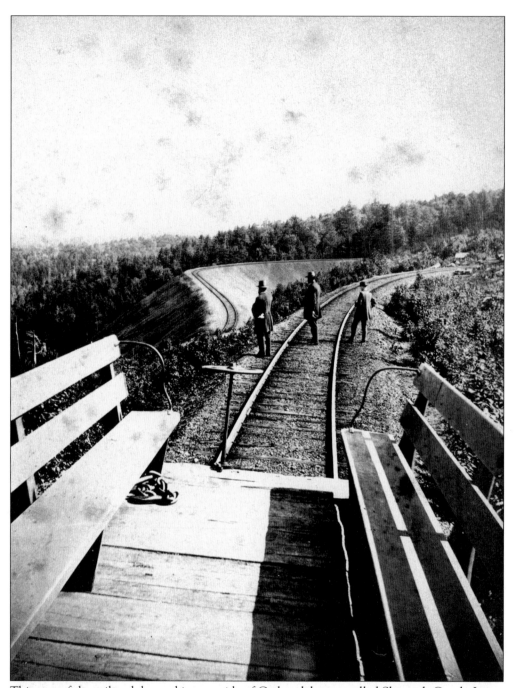

This area of the railroad, located just outside of Carbondale, was called Shepards Crook. It was constructed during the expansion of 1866 to separate loaded cars from empties. This engineering feat achieved fame both for its technical construction and its scenic beauty. The loop was 400 feet in diameter and 2000 feet in length. (Collection of the Minisink Valley Historical Society.)

This *c.* 1880s view shows Carbondale, Pennsylvania, where the Wurts brothers began purchasing their first anthracite coal fields in 1816. Prior to the War of 1812, the country had been dependent on imported British bituminous coal. The war brought a shortage, and entrepreneurs like the Wurts brothers saw the potential for domestic anthracite coal. Thus, the dream of the canal was created. (Collection of the Minisink Valley Historical Society.)

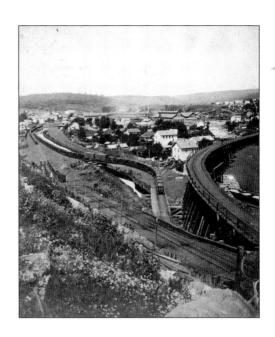

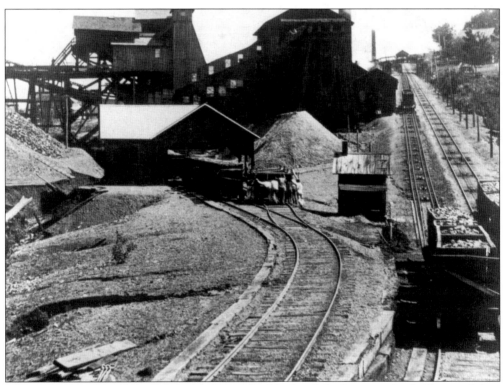

The Racket Brook breaker was located just north of Carbondale. Cars were loaded here and then pulled by horses to the foot of Plane 4. In the distance stands the smokestack for the building that housed the stationary engine. (Collection of the Minisink Valley Historical Society.)

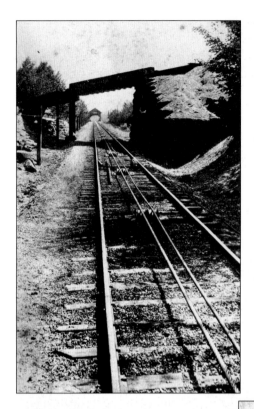

In Carbondale was Plane 1, shown here in the 1870s. The cable in the center was attached to the loaded cars, which were then pulled up the mountain by stationary engines. Linked chain was originally used, but, due to the failure of the links, hemp rope became the popular substitute. The hemp was later replaced when John Roebling developed wire rope. (Collection of the Minisink Valley Historical Society.)

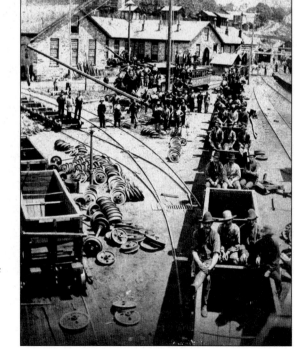

Shown here c. 1880 are the Delaware and Hudson Gravity Railroad machine shops in Carbondale. The many cars that ran on the line were built and repaired in this busy railroad yard located at the foot of Plane 1. (Dave and Cyndi Wood.)

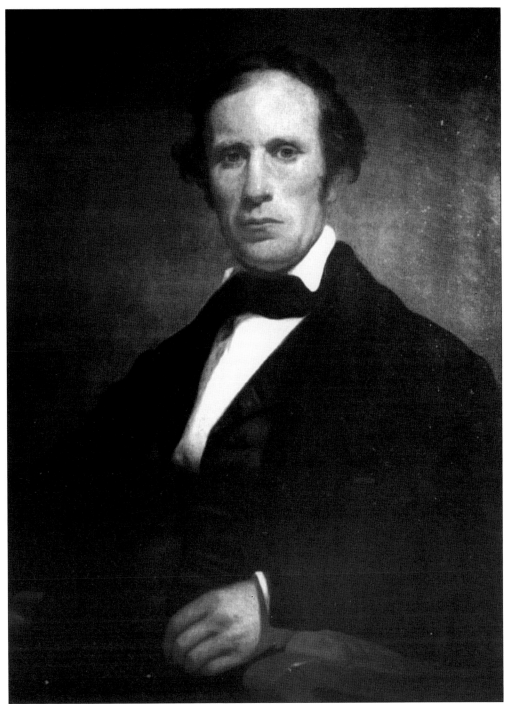

James Archbald became the second chief engineer of the Delaware and Hudson Gravity Railroad upon the resignation of John B. Jervis. He was in charge of the design and construction during the 1840s expansion phase. The borough of Archbald in Pennsylvania was named in his honor. Archbald also served as the first mayor of Carbondale from 1851 to 1855. (Collection of the Minisink Valley Historical Society.)

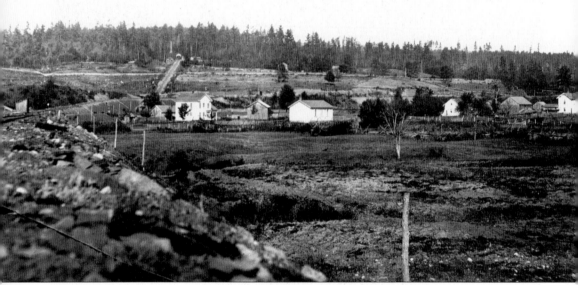

This *c.* 1860 view shows Plane E near Olyphant. The poles running along the tracks were used for telegraph wires. The Delaware and Hudson was one of the first to use this new technology for communications on a railroad. The building of the railroad and canal brought rural farms like these closer to large areas through both transportation and communication. (Robbie Smith.)

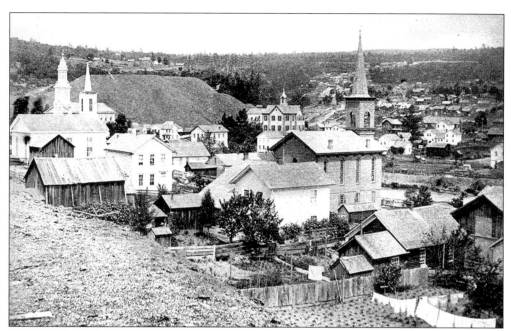

In 1843, the railroad was extended from Carbondale to Archbald. This is a c. 1880 Hensel image of the town named after the chief engineer of the railroad, James Archbald. (Dave and Cyndi Wood.)

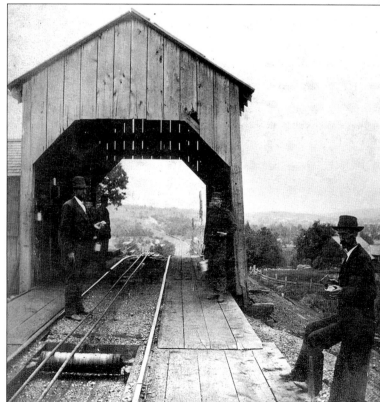

The views from the gravity railroad atop Moosic Mountains were spectacular. This one, from Plane 26 outside of Archbald, looks down at the Lackawanna Valley c. 1880. (Dave and Cyndi Wood.)

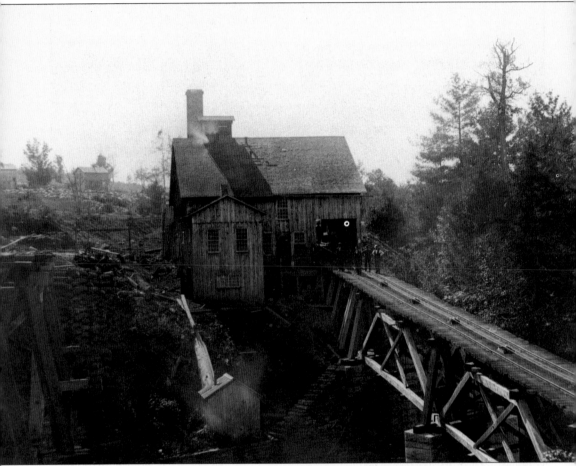

With the completion of the expansion and improvements, the railroad had 28 planes. Though they were all numbered, some were known locally by letters. This *c.* 1860 photograph shows the engine house at the head of Plane F (or Plane 22) in the Olyphant region. Note the massive trestles built to move the train up this steep grade. (Robbie Smith.)

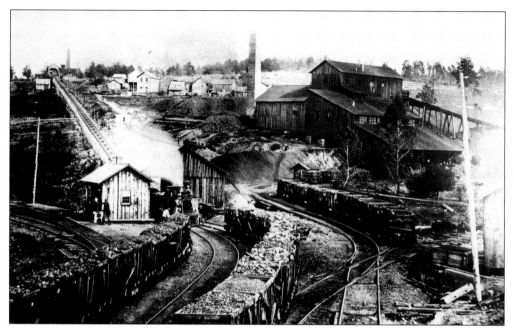

In Archbald, the railroad and coal business dominated the entire region. The amount of coal moved from this region along the gravity railroad reached its peak in 1883 at more than four million tons. (Collection of the Minisink Valley Historical Society.)

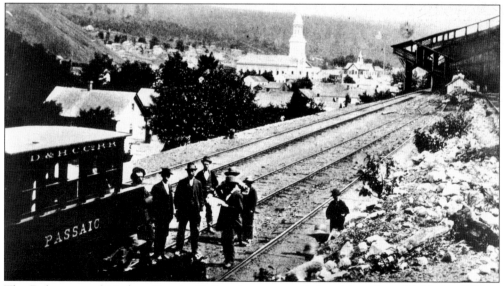

The Delaware and Hudson Gravity Railroad was expanded and lengthened again in 1858 to Valley Junction near Olyphant, Pennsylvania. This town was named after George Talbot Olyphant, president of the Delaware and Hudson Company from 1858 to 1868. Many towns in this area were named after men associated with the D & H. This included Dickson City, which was named after Thomas Dickson, who succeeded Olyphant as president. (Collection of the Minisink Valley Historical Society.)

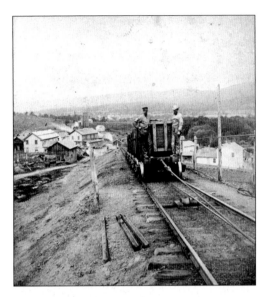

In this *c.* 1880s Hensel view, five loaded cars are being pulled up from Valley Junction. At its height of operation, the Delaware and Hudson ran 5,000 cars capable of hauling five tons of coal. (Dave and Cyndi Wood.)

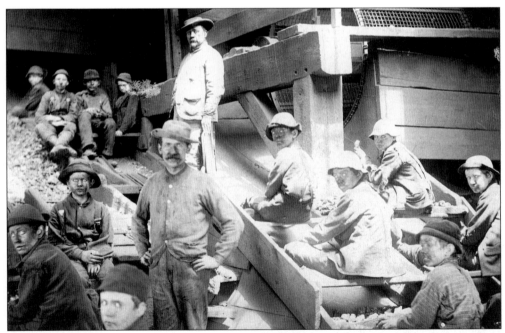

With the expansion of the railroad, coal mines flourished in northeastern Pennsylvania. These mines provided employment for the young and old. The Greenridge Colliery outside of Scranton was where young boys spent long hours separating slate from coal *c.* 1880. The final extension of the Delaware and Hudson Railroad in 1863 ended the line in Scranton. (Dave and Cyndi Wood.)

When the gravity railroad was first constructed much of the work of loading and unloading coal was manual. The Delaware and Hudson was a very progressive company, always looking at new technology and ways of cutting costs. This *c.* 1880 view shows a steam shovel being operated at the Honesdale loading docks. (Dave and Cyndi Wood.)

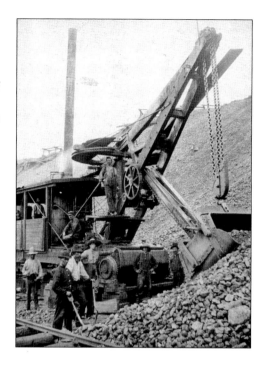

This view down the valley is from the head of Plane 11 near Waymart. The building on the left housed the stationary engine. The steam engine flywheel is visible. Another pulley inside of the building ran the wire rope that pulled the cars up the steep slopes. (Dave and Cyndi Wood.)

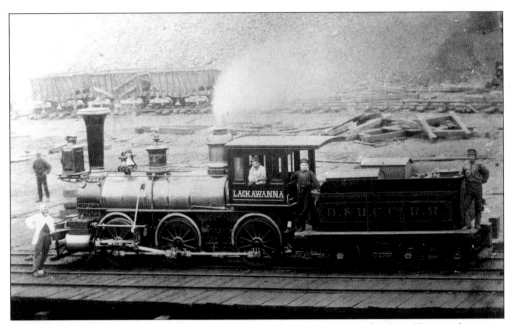

When the railroad expanded to Providence, Pennsylvania, in 1860, the D & H started to use a new form of power—steam. The company had engines built, like the Lackawanna No. 4. Finished in 1862 at Dickson Manufacturing, she rode the line proudly until 1899, when she was scrapped. (Collection of the Minisink Valley Historical Society.)

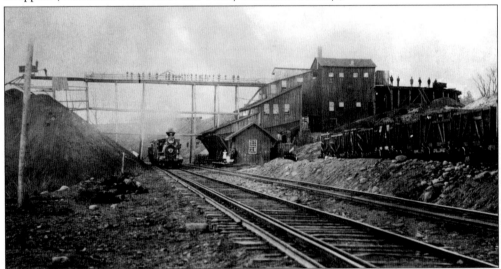

A locomotive moves along the tracks outside Carbondale in this *c.* 1880s photograph. As early as the 1860s, the management of the D & H began investing in railroads, anticipating the closing of the canal and wanting to continue shipping coal. When the canal closed, the Delaware and Hudson Canal Company became the Delaware and Hudson Company, continuing as a leader in transportation. It is fitting that the company that ran the first steam locomotive in the United States was also one of the first to operate diesel engines. Always in the forefront of innovation, the Delaware and Hudson Company operated for more than 160 years. In 1987, it filed for bankruptcy and was acquired by the Canadian Pacific Railroad in 1990. (Collection of the Minisink Valley Historical Society.)

Two
HONESDALE TO LACKAWAXEN

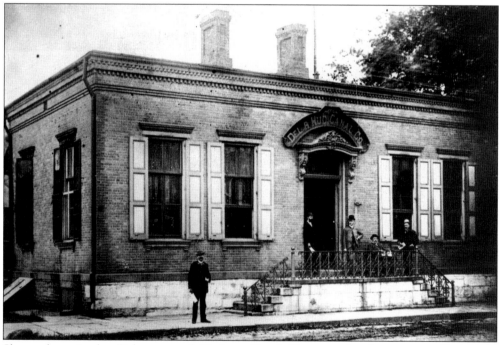

Shown here is the Delaware and Hudson Canal Company headquarters in Honesdale, Pennsylvania c. 1880. This building was the northern command post for the everyday operation of the canal and the railroad. This Honesdale landmark stands today as the home of the Wayne County Historical Society. (Collection of the Minisink Valley Historical Society.)

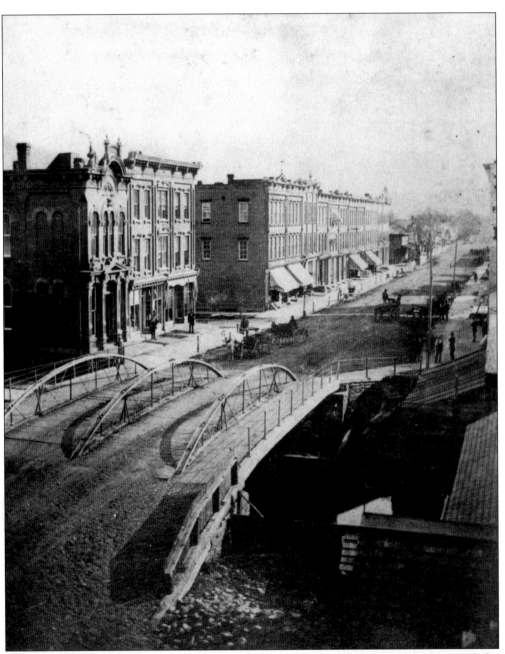

This c. 1880s view shows Honesdale, as viewed from across the bridge that separated the Honesdale Basin and what was known as the Wilbur and Patmore Basin. The town of Honesdale was the transportation hub for the Delaware and Hudson Canal Company. Here, the gravity railroad terminated, and the canal began its 108-mile run to Kingston, New York. Prior to the canal, this area was a sparsely populated spot known as Dyberry Forks. (Collection of the Minisink Valley Historical Society.)

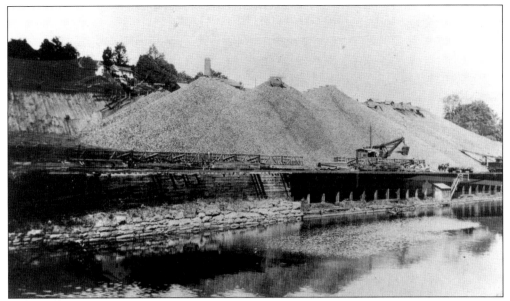

Honesdale has been credited with having the largest storage area for coal in the country during most of the 19th century. This c. 1880 photograph seems to prove this claim. These storage piles were built up during the winter months when the canal was frozen over and the railroad continued to operate. (Collection of the Minisink Valley Historical Society.)

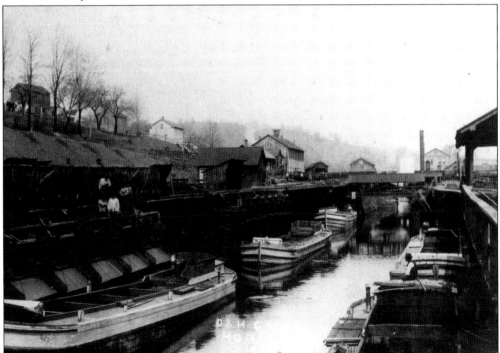

In the upper Honesdale Basin, canal boats are lined up to be loaded with coal. This c. 1885 image shows three boats, each in a different stage of loading. The first boat is empty, the middle is full, and the boat in the foreground is being loaded. (Collection of the Minisink Valley Historical Society.)

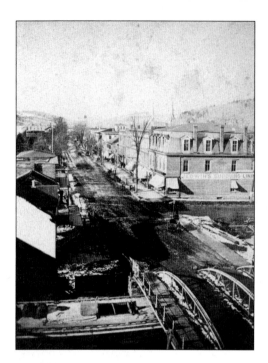

This Hensel view depicts Honesdale's business district. The canal company employed many of the residents of this hamlet. The work was hard and strenuous; the use of a liniment for aching muscles must have been a popular remedy, as exemplified by the advertising on the building. (Dave and Cyndi Wood.)

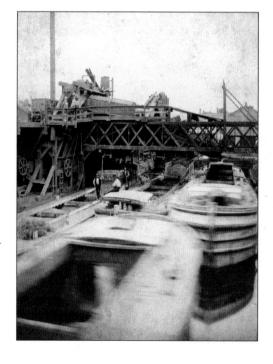

There were times when hundreds of boats were lined up in Honesdale. At the height of its operation, the canal had nearly 1,100 boats using its waterway. Many of these boats hauled coal while some ran local products. This c. 1880 Hensel view shows the coal screening area at the canal docks. (Dave and Cyndi Wood.)

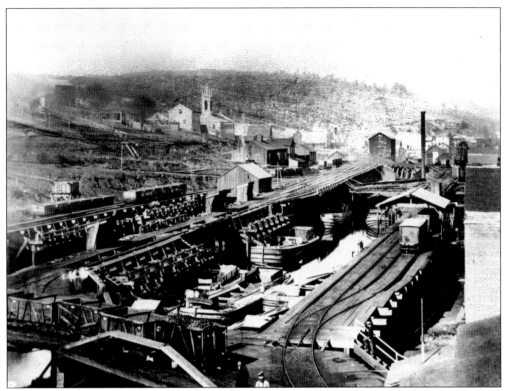

The junction of the gravity railroad and the canal was known as the Dog Nest. Here, the coal was separated by size with large revolving screens and then loaded and sent on its way to Kingston. This photograph was taken *c.* 1880. (Collection of the Minisink Valley Historical Society.)

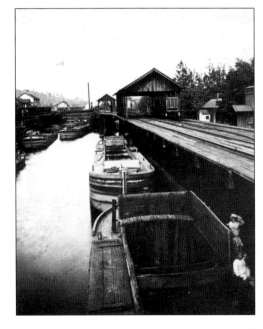

This early view depicts the coal loading docks in Honesdale. A pair of youngsters pose for the photographer while waiting to be loaded with their share of anthracite coal from the huge stock piles. (Dave and Cindy Wood.)

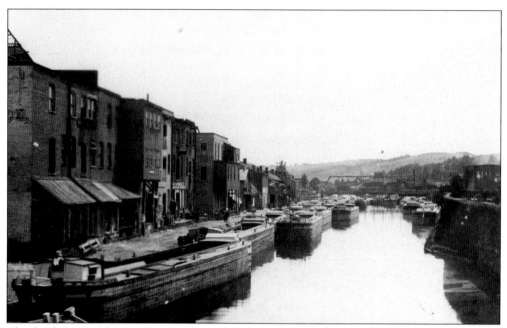

The loaded canal boats, some carrying 140 tons, moved through the Honesdale Basin by manpower. Canalers manipulated long poles, pushing off the bottom to propel the barge. Only here and in the Rondout Creek was this type of power allowed. The "poling down" practice was not permitted on the canal for fear of puncturing the wall and causing a break. (Collection of the Minisink Valley Historical Society.)

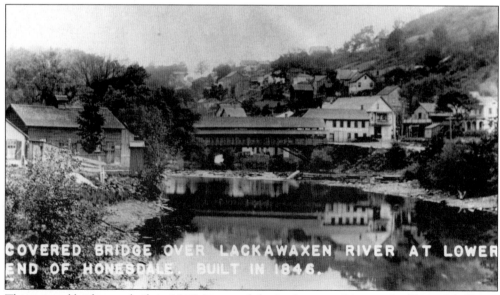

COVERED BRIDGE OVER LACKAWAXEN RIVER AT LOWER END OF HONESDALE. BUILT IN 1846.

This covered bridge was built in 1846. It crossed the Lackawaxen River at the Honesdale Basin. (Collection of the Minisink Valley Historical Society.)

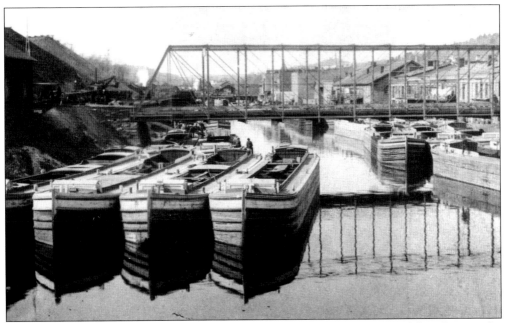

A large group of empty boats rests under the Terrace Street Bridge. In front of these boats is the first set of locks. These were double locks and the only set on the entire 108 miles. Notice to the left the massive mountain of coal. This photograph was taken c. 1880. (Collection of the Minisink Valley Historical Society.)

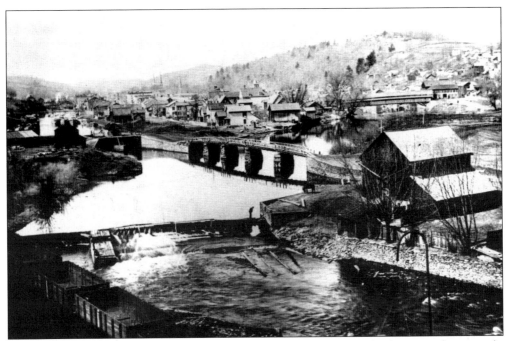

This c. 1890s view looks across the Lackawaxen River. The bridge in the front was the towpath, where teams of mules or horses rode to pull their loads. The canal began behind the building to the right. (Collection of the Minisink Valley Historical Society.)

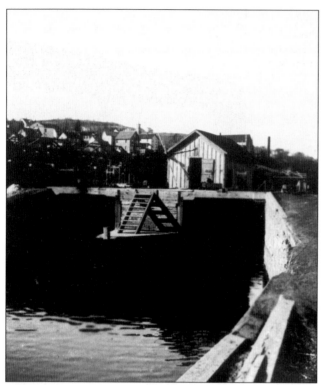

A view of the only double-lock system on the entire canal was located at the lower end of the Honesdale Basin. These locks, numbered 37 and 38, allowed the loaded and empty boats to move together on the canal. (Collection of the Minisink Valley Historical Society.)

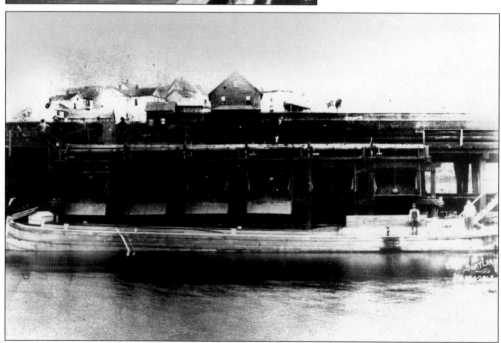

The final boat to complete a full run of the canal left Honesdale on November 5, 1898. Boat No. 1107 was commanded by Captain Hensberger. After 70 years of operation, the canal that had moved millions of tons of coal ceased full operation. (Collection of the Minisink Valley Historical Society.)

A sunken canal boat rests on the canal bottom in the Honesdale Basin in this c. 1880 view. This boat had to be unloaded by hand then taken to a dry dock, where it was repaired. (Dave and Cyndi Wood.)

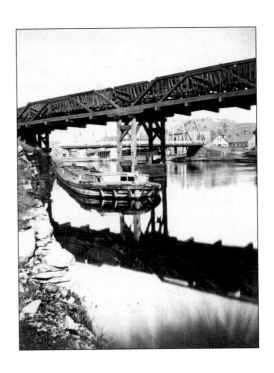

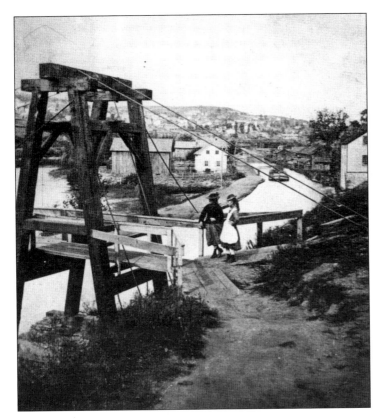

In this c. 1875 view, a loaded canal boat travels toward the Delaware, one mile east of Honesdale. At this area, called Leonardsville and also known as Chris Lanes, a boatyard was operated by Christopher Lane. In many spots along the canal where there were large areas of water, dry docks were established. These yards provided space for boats to be repaired and built. (Robbie Smith.)

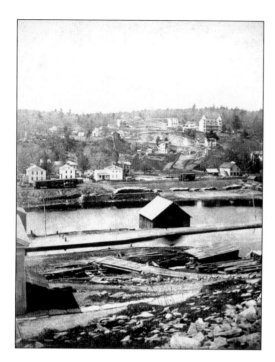

The town of Hawley, c. 1880s, was the next town canalers entered after leaving Honesdale. The town is named after the first president of the Pennsylvania Coal Company, Irad Hawley. This area was initially called Paupack Eddy, then Hawleysburgh, and finally, in 1851, Hawley. Like many towns in the area, names were taken from leaders of the coal industry, transforming this entire region. (Dave and Cyndi Wood.)

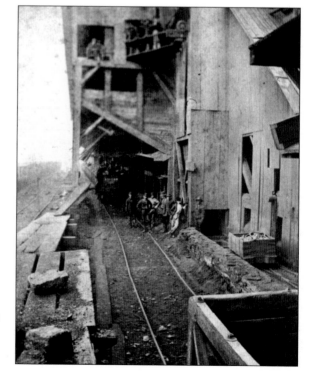

In the late 1840s, the Pennsylvania Coal Company built a gravity railroad from Port Griffith, Pennsylvania, to Hawley. According to E.D. Leroy, the development, "mushroomed Hawley overnight from a raftsman's village of a few houses into a booming town." Shown here are the coal pockets built by the coal company c. 1880. (Dave and Cyndi Wood.)

The Pennsylvania Coal Company Gravity Railroad was 47 miles long. It moved its first coal to Hawley in 1850 under an agreement that the Delaware and Hudson would purchase and ship the coal via the canal. In this c. 1880 photograph, a loaded train is pulled up Plane 2, destined for Dunmore, Pennsylvania. (Dave and Cyndi Wood.)

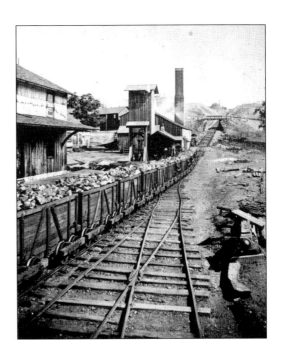

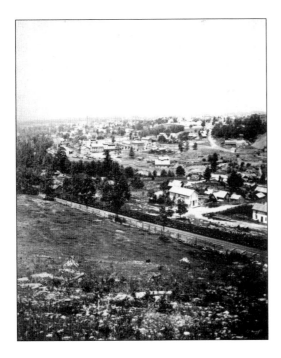

This is an early view of Dunmore, as seen from the Pennsylvania Coal Company Gravity Railroad. Travelers on this route delighted in the spectacular valley views of the Moosic Mountains. (Dave and Cyndi Wood.)

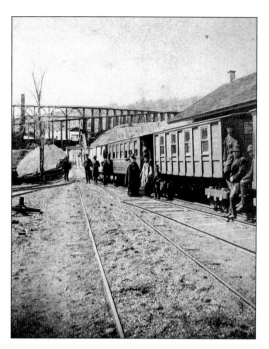

The gravity railroad out of Hawley operated for 35 years. In the mid-1850s, it shipped 500,000 tons of coal on the canal, but soon the agreement with the Delaware and Hudson turned into a court battle over tolls charged. The Pennsylvania Coal Company then built a railroad through to Lackawaxen, continuing its operation in Hawley until 1885, when the coal pockets were abandoned. This c. 1880 view depicts Plane 13 at Hawley. (Dave and Cyndi Wood.)

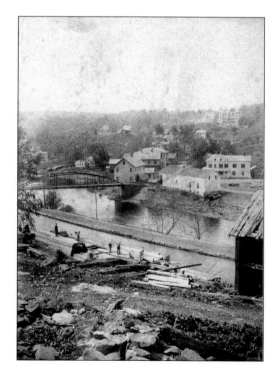

This c. 1880s view shows Hawley from behind the canal. Although the owners of the D & H built the canal to move coal, towns found the canal to be a great way to transport local products to new markets. These men prepare lumber for shipment. (Dave and Cyndi Wood.)

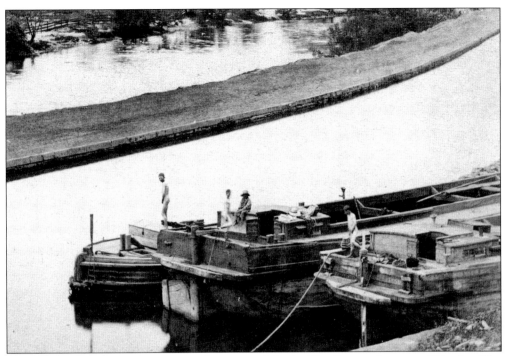

On the entire 108 miles there were only two weigh locks. The first was just east of Hawley. The second was 100 miles east at Eddyville. The weight of cargo not traveling the full length of the canal was calculated at these locks. The canal boats entered, and then the lock master emptied the lock, determining the weight of the cargo. This photograph was taken *c.* 1870 by Edward Anthony from the Hawley weigh lock. (Dave and Cyndi Wood.)

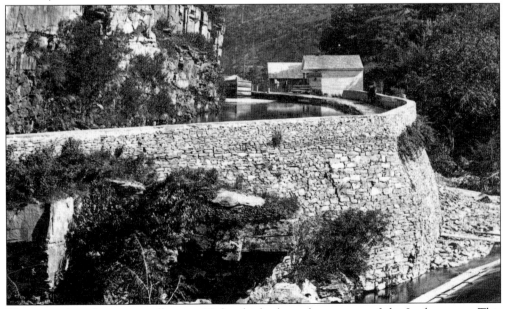

These massive, dry stone walls were 30 feet high along the narrows of the Lackawaxen. This section of the river—being only 40 feet wide—forced the construction of these incredible stone walls. This photograph was taken *c.* 1870. (Dave and Cyndi Wood.)

William Cronk, a blacksmith on the narrows of the Lackawaxen, poses for Edward Anthony in the 1870s. The blacksmith was a necessity for the canalers and their teams of mules and horses. (Dave and Cyndi Wood.)

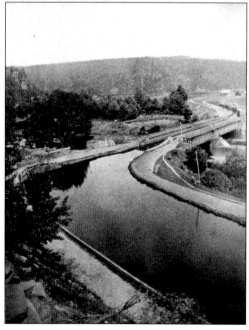

The canalers followed the Lackawaxen for 16 miles and passed through 26 locks before approaching the Lackawaxen Aqueduct, c. 1880. (Dave and Cyndi Wood.)

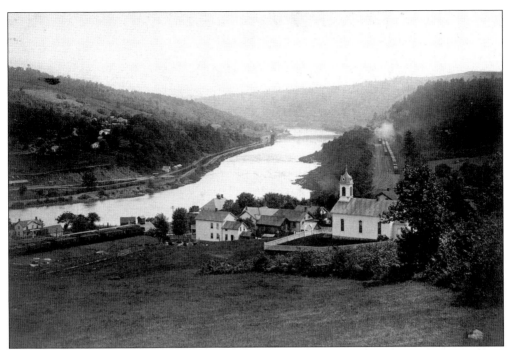

This *c.* 1889 scene shows the small town of Lackawaxen located on the banks of the Delaware River. On the New York side, the buildings of Lock 71 and 72 can be seen. (Collection of the Minisink Valley Historical Society.)

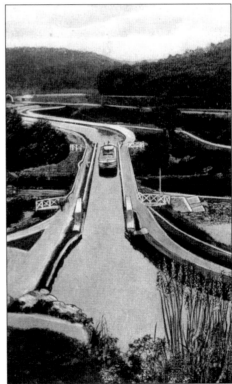

The Lackawaxen Aqueduct was the first of four suspension bridges that eastbound canalers had to cross before reaching Kingston. This aqueduct, built in 1848 by John Roebling at a cost of $18,650, was only two miles from the Delaware Aqueduct. The west abutment is all that remains of this aqueduct. It is shown here *c.* 1890. (Collection of the Minisink Valley Historical Society.)

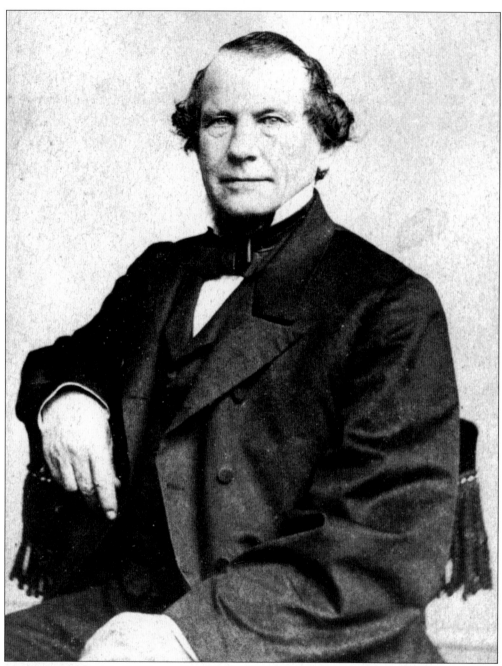

Russel F. Lord (1802–1867) was the chief engineer during the construction of the Roebling Aqueducts. It was Lord who, after inspecting Roebling's work in Pittsburgh, recommended the suspension bridge design. Hired in 1828 as a young engineer, Lord quickly moved into the position of chief and became instrumental in the expansion of the canal. In 1828, the canal was built 28 feet wide at the top, 20 feet wide at the bottom, and 4 feet deep. In 1852, the canal was expanded to 48 feet, 30 feet, and 6 feet, respectively. This also included the creation of four new aqueducts and the redesign of the 108 locks—all led by Russel F. Lord. (Collection of the Minisink Valley Historical Society.)

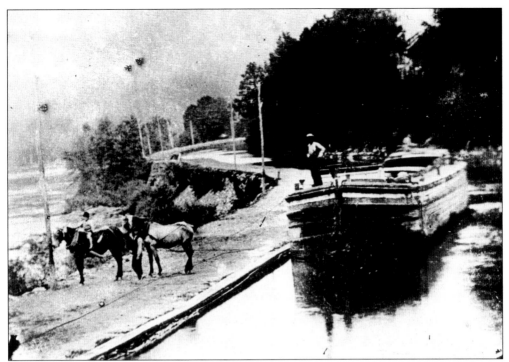

Shown here is a typical work day on the Ditch, as the Delaware and Hudson was called. This *c.* 1875 photograph depicts Boat No. 1 with Capt. Thomas M. Terwiller. Ed P. Terwiller sits on a mule back, while Jimmy White stands. A full crew is on hand for a day's work. (Collection of the Minisink Valley Historical Society.)

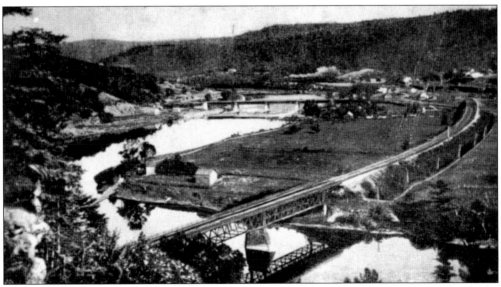

Shown here is an 1890s view of the Lackawaxen Valley with the Erie Railroad Bridge in the forefront and the Delaware Aqueduct in the distance. In the lower left corner is a floating bridge crossing the Lackawaxen. The remnants of the original canal, which preceded the aqueduct, can be seen in the distance across the Delaware River. (Robbie Smith.)

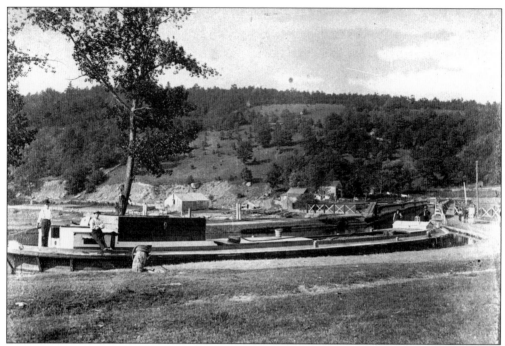

The canalers' first view of the Empire State was at the entrance of the Delaware Aqueduct. While an empty boat crosses back toward Honesdale, a loaded boat waits, tied to a snubbing post. (Robbie Smith.)

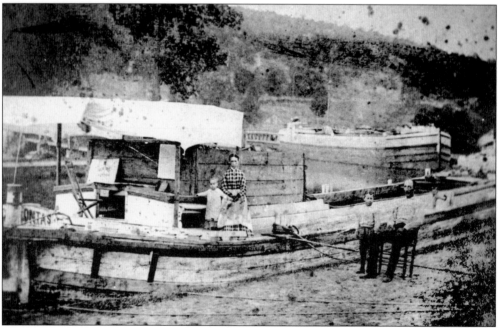

The canal boat *Pocahontas* takes a rest at the Lackawaxen Aqueduct. All boats were numbered, but many owners named their boats too. The journey on the canal was 10 days round-trip, and the entire family worked for the whole season. (Collection of the Minisink Valley Historical Society.)

Three

MINISINK FORD TO BOLTON LANDING

The Delaware Aqueduct, as seen in this *c.* 1880s photograph, was completed in 1848 at a cost of $41,750. For more than 150 years, the suspension structure designed by John Roebling has withstood all the elements. The bridge comprising four spans was originally 19 feet wide at water line and 6 feet deep. The two main cables, at eight and a half inches in diameter, could hold 1,900 tons. The total weight of the cables and anchor chains was 490,000 pounds. This bridge, now owned by the National Park Service, is one of the oldest suspension bridges in the western hemisphere. (Collection of the Minisink Valley Historical Society.)

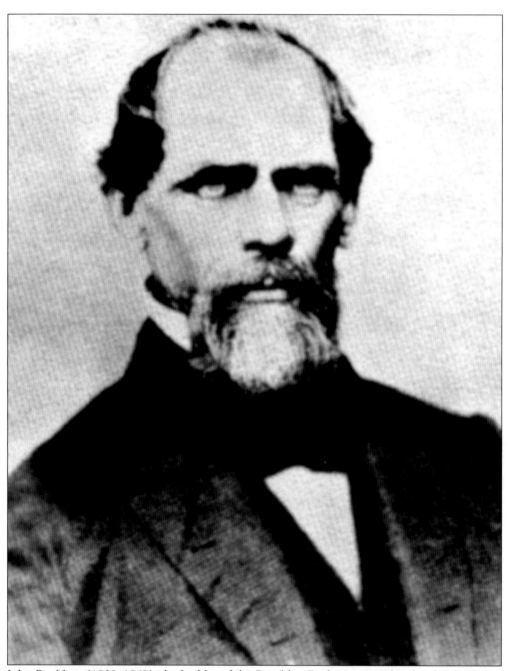

John Roebling (1809–1869), the builder of the Brooklyn Bridge, is considered to be the father of the modern-day suspension bridge. His invention of twisted steel cable led this design. Roebling was the engineer commissioned by chief canal engineer Russel F. Lord in 1847 to construct the first of the aqueducts. He was to build a total of four aqueducts on the Delaware and Hudson Canal. (Collection of the Minisink Valley Historical Society.)

This *c*. 1870s view shows the magnificent Delaware Aqueduct. The Roebling design was chosen primarily because it used only three piers, thereby allowing more room for ice floes and leading to less expensive maintenance. The 535-foot structure has four spans, each capable of holding 489 tons of water. This was a truly incredible engineering feat of the 1840s. (Dave and Cyndi Wood.)

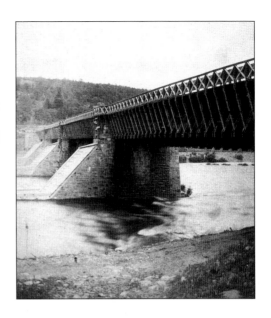

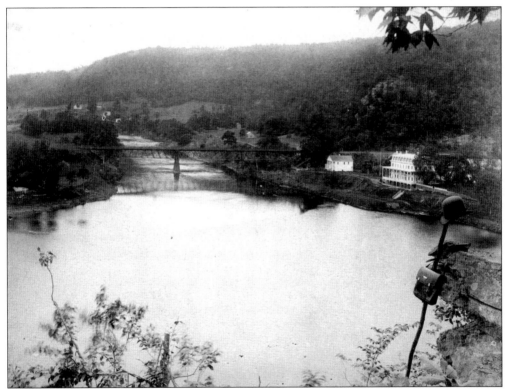

On a clear summer day in the 1880s, this dapper photographer captured a beautiful scene of the confluence of the Lackawaxen and Delaware Rivers. The construction of a dam just down the stream created the calm waters seen in the river. The original canal flowed directly in front of the hotel to the right. In that area were three original locks, which were abandoned when the aqueducts were built. (Collection of the Minisink Valley Historical Society.)

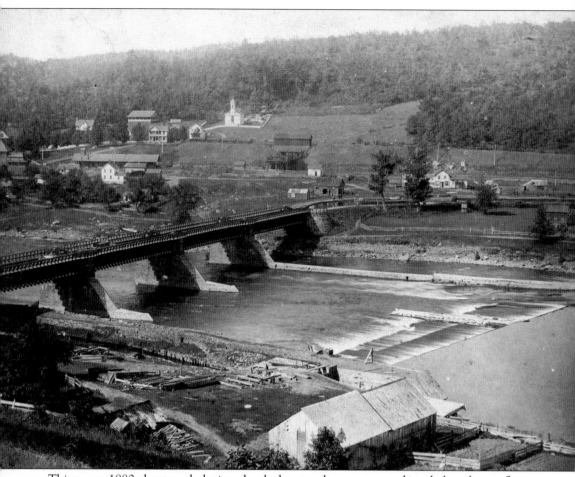

This rare c. 1880 photograph depicts the slack water dam constructed just below the confluence of the Delaware and Lackawaxen Rivers. This dam caused a one-and-a-quarter-mile calm section in the river. This slowing of the water allowed the canal boats to be pulled across the river by a rope ferry. The original canal (1828–1848) followed along the Lackawaxen and dropped through three locks, where it met the ferry. This crossing was slow and resulted in delays, especially during high water, when the crossing was impossible. Another problem was with raftsmen moving lumber down the river. The traffic of slow-moving canal boats and fast-moving rafts coming down the river was a major hazard. The raftsmen complained continually about the dam and its danger. They either had to shoot over the dam or use the sluiceway on the Pennsylvania side, which can be seen in this photograph. These problems led to the building of the aqueducts on this section of the canal. (Collection of the Minisink Valley Historical Society.)

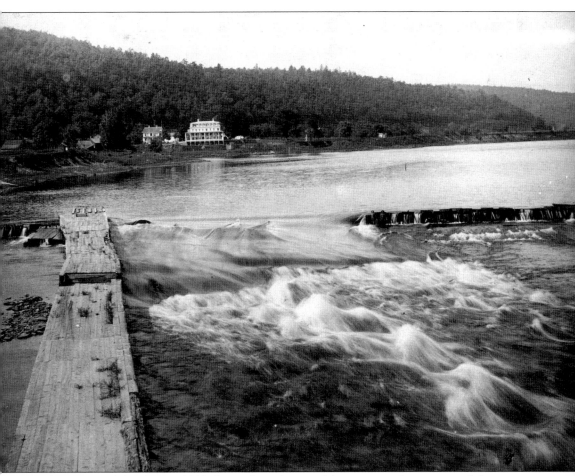

A closer view of the dam *c.* 1880 shows the velocity of the water at this section of the river. Originally 6 feet high, it was raised to 16 feet after the completion of the aqueduct. The increase in height created a larger pool for canal-feeding purposes. This became a very treacherous section for raftsmen. When a raft went over the dam, the bow oarsmen disappeared from the stern oarsmen under a swirl of white water. Many rafts of lumber were lost on this section of the river, and the Delaware and Hudson paid the damages. In an attempt to aid raftsmen, the D & H provided guides to lead rafts through this dangerous section, but this was not done without a payment to the canal company. The Delaware House sits in the distance at the confluence of the Lackawaxen and Delaware Rivers. (Collection of the Minisink Valley Historical Society.)

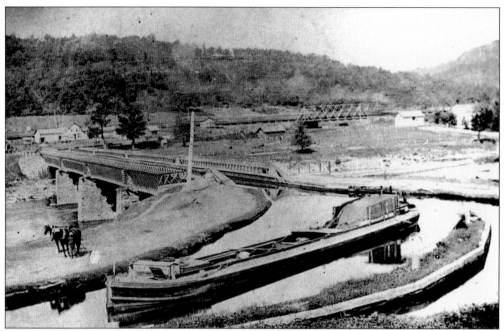

After entering New York across the Delaware Aqueduct, canal boats turned sharply right and proceeded through Locks 72, 71, and 70 in quick succession. In the distance is the Erie Railroad Bridge in Lackawaxen, Pennsylvania. (Collection of the Minisink Valley Historical Society.)

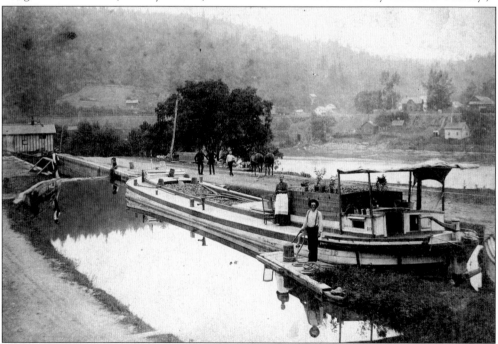

This view across the Delaware River from Minisink Ford, New York, shows the Erie Railroad tracks in the distance. The loaded canal boat waits to proceed into Lock 72, with another boat right behind. The canal continued through a total of 16 locks before reaching Port Jervis, New York. (Collection of the Minisink Valley Historical Society.)

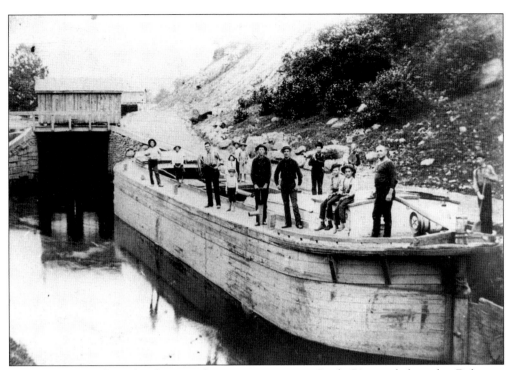

This light canal boat heading north prepares to enter Lock 71 just below the Delaware Aqueduct at Minisink Ford. The canal employed all ages, as can be seen in this c. 1880s photograph. In the distance is Lock 72, the first lock in New York. (Robbie Smith.)

The canal followed the Delaware Valley and crossed two smaller aqueducts before reaching Barryville, New York. This town, established in 1831, grew around the canal and, by 1872, thrived with blacksmith shops, gristmills, boat-building businesses, and 259 residential homes. The canal can be seen in the far right center. The bridge to Shohola, Pennsylvania, spans the Delaware River. (Collection of the Minisink Valley Historical Society.)

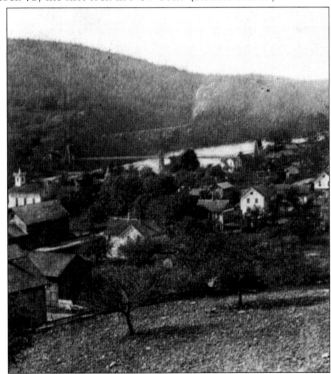

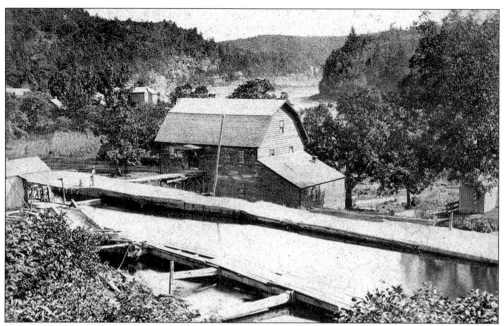

This c. 1870s view looks east from Barryville. Canal boats went through two locks while passing through the small town. This view was taken from above Lock 68, just below the Barryville Basin, with the Delaware River in the distance. (Dave and Cyndi Wood.)

Canal boats were 78 miles from Rondout when leaving Barryville and Lock 68. This lock, like most of the 107 locks on the canal, had a lift of 10 feet. Shown is a c. 1870s photograph. (Dave and Cyndi Wood.)

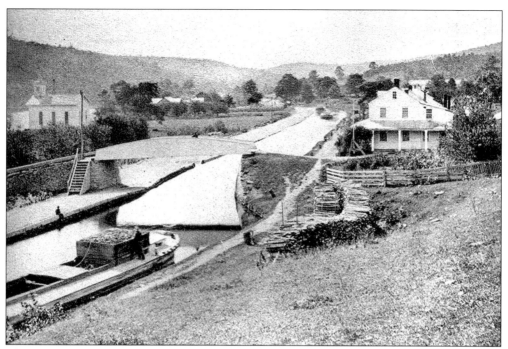

This *c.* 1870s view looks north, and a canal boat in the distance is seen coming through Lock 69, east of Barryville. On average, it took 20 minutes and nearly 10,000 gallons of water for a boat to come through a lock. In the distance, loaded boats head toward Kingston, New York. (Dave and Cyndi Wood.)

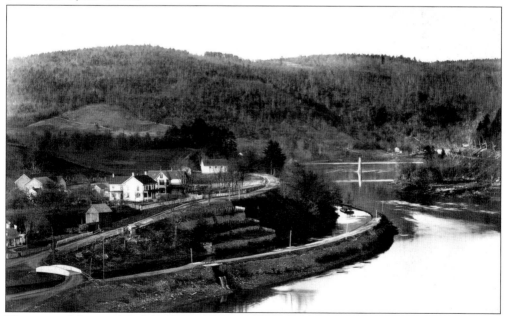

This view of the canal and the Delaware River exemplifies the beauty of the two waterways. In the background is the Pond Eddy Bridge; Pond Eddy is the next town along the canal way. The waste weir visible in this *c.* 1890s photograph was necessary to control the height of the water in the canal. (Robbie Smith.)

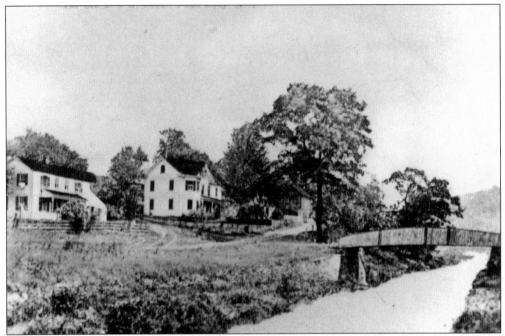

This picture was taken after the canal ceased operation in 1898. For nearly 70 years, these canal boats passed by homes and farms in Pond Eddy. (Collection of the Minisink Valley Historical Society.)

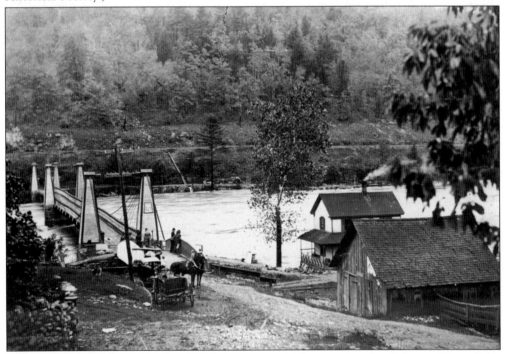

This c. 1890s view shows the Pond Eddy suspension bridge crossing the Delaware River. This bridge was erected in 1871 just north of Lock 63. The river, running fast and furious through this scene, is in a flood stage. (Robbie Smith.)

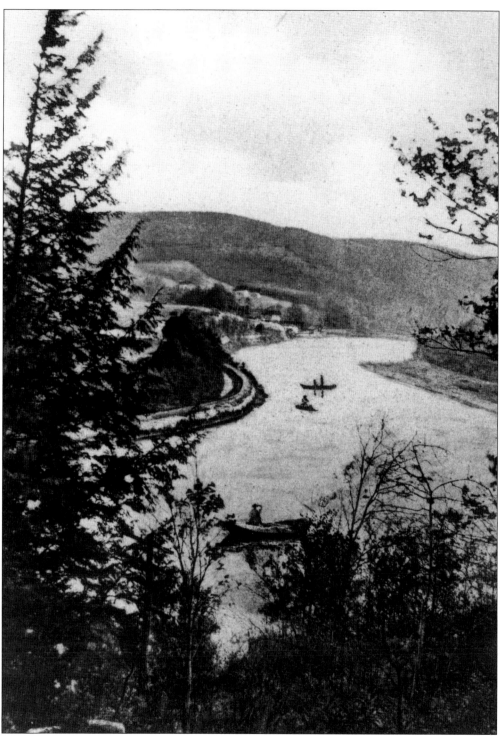

Shown here is a majestic view of the Delaware Valley. The canal followed the banks of the river for approximately 25 miles before turning east in Port Jervis. (Collection of the Minisink Valley Historical Society.)

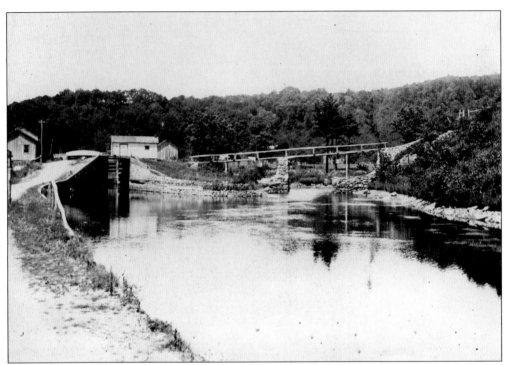

The area of Mongaup in Sullivan County, New York, developed around the construction of the canal. Here, the company needed two locks and a wooden trunk aqueduct to cross the Mongaup River. This c. 1890s photograph shows Lock 59, which raised the canal for the aqueduct. (Robbie Smith.)

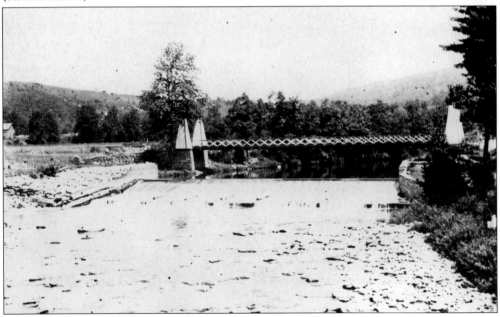

In this view, the old Mongaup Suspension Bridge crosses the feeder dam c. 1890. The water from the Mongaup fed into the canal on the right and was one of the 16 dams used to keep the canal filled. (Robbie Smith.)

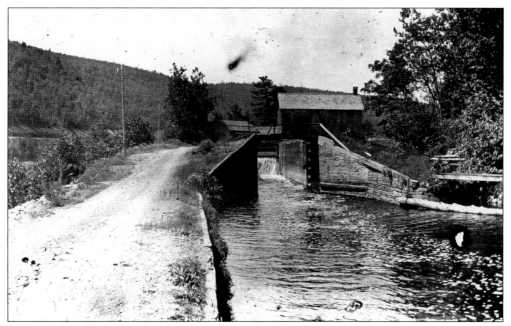

Just east of the Mongaup Aqueduct was Lock 58, seen here. The 107 locks were originally built 9 feet, 6 inches wide and 75 feet long. In 1852, their size increased to 15 feet wide and 90 feet long due to the use of larger boats capable of carrying 130 tons of coal. It was said that a boat fit into the lock like a hand in a glove. (Robbie Smith.)

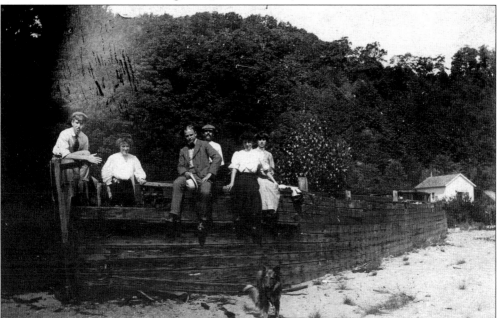

This family in 1912 seems to enjoy posing in their own abandoned canal boat in the drained canal bed in Mongaup. When the canal closed in 1898, all of the waste weirs and locks were opened and the canal was drained from Honesdale to Ellenville. In the next few years, all of the property was sold and the canal became history. (Collection of the Minisink Valley Historical Society.)

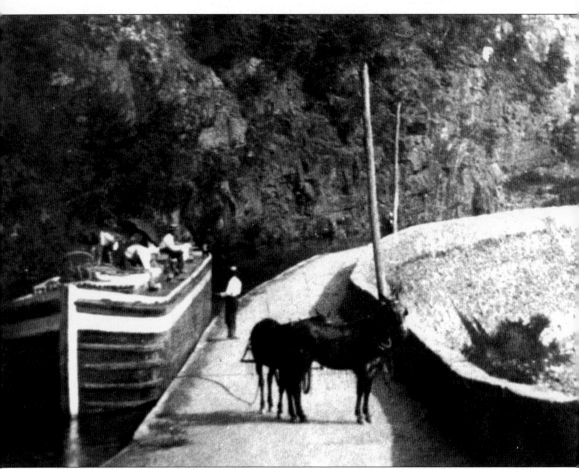

The Hawk's Nest presented a grand backdrop for the canal. The mountains here rose a sheer 300 feet above the Delaware River; the canal was built hugging those cliffs. The walls in this picture stand 40 feet above the riverbed. This area, as well as that along the Lackawaxen, is where some of the most labor-intensive work on the canal occurred. In this photograph, a light boat heads toward Butler's Lock while, in the distance, a loaded boat moves down the canal. (Collection of the Minisink Valley Historical Society.)

The real workers of the canal were the mules and horses. These animals walked up to 3,000 miles in a single season. Here, Andrew Paye (visible in the background) poses with his faithful workers. (Collection of the Minisink Valley Historical Society.)

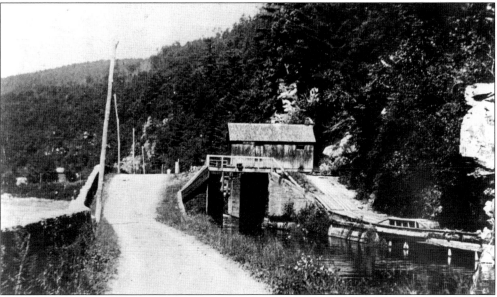

Lock 57, also known as Butler's Lock, was just west of the Hawk's Nest. Here, the canal started a 12-mile level pass to the Neversink River. This lock was one of the most isolated on the canal, with many of the others having towns and stores nearby. It was named after General Butler, an associate of Chief Joe Brandt of the Battle of Minisink. Shown is a c. 1890s photograph. (Robbie Smith.)

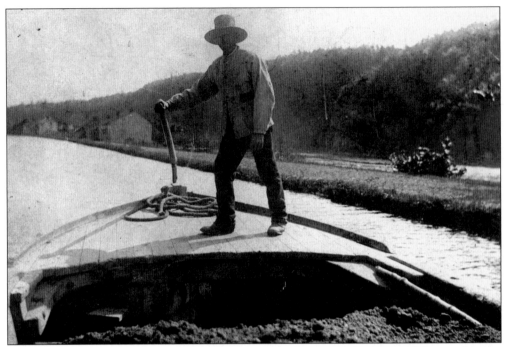

Capt. John Hull steers his boat, the *Hook*, through the Sparrowbush section of the canal in the 1880s. At this time, the use of the canal was declining, and the end was in sight. In its lean years of the 1850s, as many as 1,100 boats navigated the canal's banks, with an average round trip of 15 days. The captains hoped—with no delays—to make 16 trips per season. That amounted to more than 3,000 miles of canal travel. (Collection of the Minisink Valley Historical Society.)

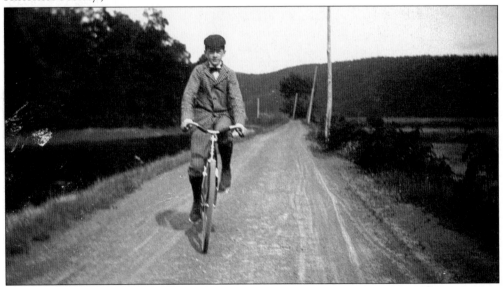

This young man bicycles along the towpath after the canal's closure. In the years of operation, the canal company frowned on people using the towpath for pleasure. However, when the canal closed, a suggestion was made to convert the towpath into a bicycling path for both pleasure and endurance races. I wonder if this man biked the entire 108 miles. (Robbie Smith.)

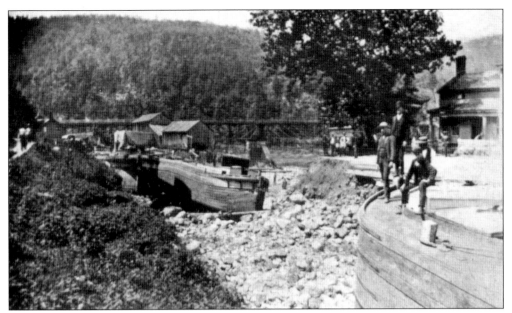

The Sparrowbush section of the canal experienced more than its fair share of disaster. In 1870, a bridge spanning the canal collapsed, and, in 1882, a train fell into the canal. On August 5, 1885, intense rains resulted in the rise of all local streams and rivers. The rapid increase in water level caused two major breaks in the canal. This photograph reveals the site of the first break, which occurred at 8:00 p.m., when all of the boats were tied up for the night. At this break, a 100-foot-long by 20-foot-deep section of the canal was washed away. (Robbie Smith.)

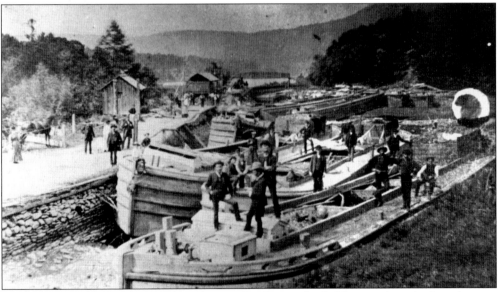

This view shows the second break in the canal at Sparrowbush. The canal was built with waste weirs that were to be used for the release of excess water, but this torrential rain proved them ineffective. As the water rose and the waste weir filled with debris, the second break occurred at 10:00 p.m. This break was more severe—200 feet long by 25 feet deep—destroying 19 boats in the basin. These incredible breaks were repaired within 10 days. (Collection of the Minisink Valley Historical Society.)

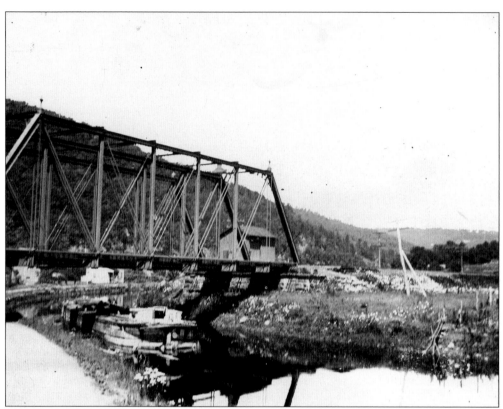

This photograph, taken after the canal closed, shows the Erie Railroad Bridge, which crossed the canal in Sparrowbush. The sunken canal boat was anchored there to stop the Erie Railroad from throwing cinder into the canal. (Robbie Smith.)

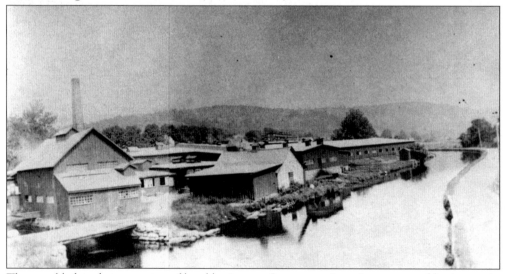

The canal led to the expansion of local businesses. In some regions, it encouraged businesses in lumber, stone, and glass. In Sparrowbush, a tanning business thrived in this location. As many as 50,000 hides were processed annually and shipped on the Delaware and Hudson Canal. (Robbie Smith.)

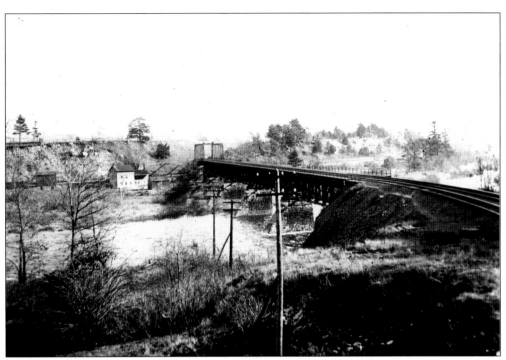

Shown here is a *c.* 1900s view toward Bolton Basin as seen from Mill Rift, Pennsylvania. The first canal break of 1885 occurred in the area at the far left of this photograph. (Robbie Smith.)

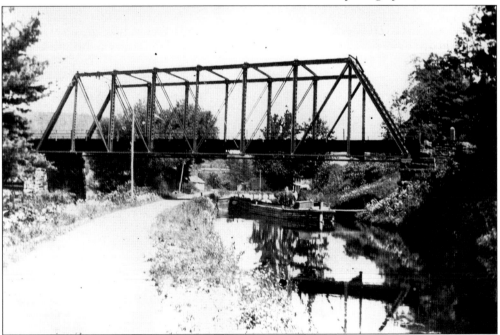

This view under Railroad Bridge No. 2 shows Bolton Basin Hotel in the distance. The bridge was also known as the Sawmill Rift Bridge. This area along the canal was named for the second president of the canal company, John Bolton, and was a favorite layover for canalers. (Robbie Smith.)

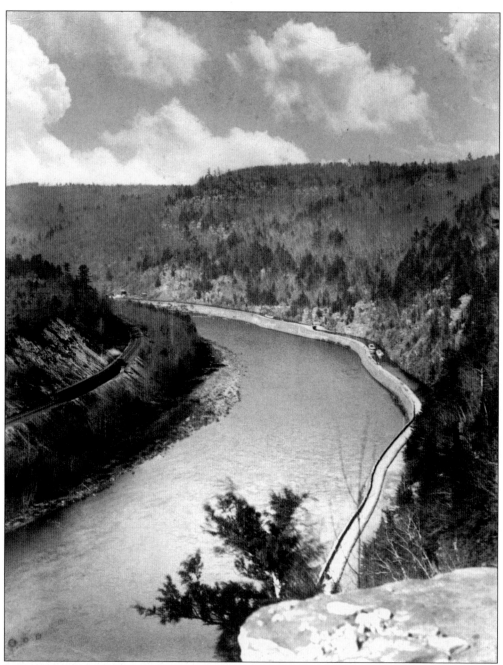

In this spectacular view, the canal is shown as it snakes its way along the Delaware Valley. When Washington Irving traveled the canal with his friend Philip Hone, the first president of the D & H, he remarked that it, "would have been famous if it had been Europe."(Collection of the Minisink Valley Historical Society.)

Four

PORT JERVIS TO
WURTSBORO

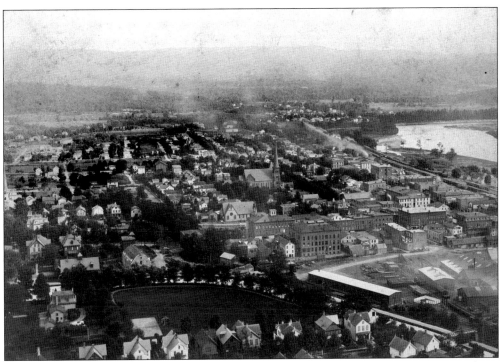

The city of Port Jervis, known in the 1820s as Carpenter's Point and Sawmill Rift, was a large bustling community when this picture was taken in 1885. Its development was greatly impacted by the Delaware and Hudson Canal and, later, the Erie Railroad. The canal can be seen in the lower part of this photograph showing the Western Basin. Port Jervis had two basins and was a major terminal on the canal. (Robert Hartman.)

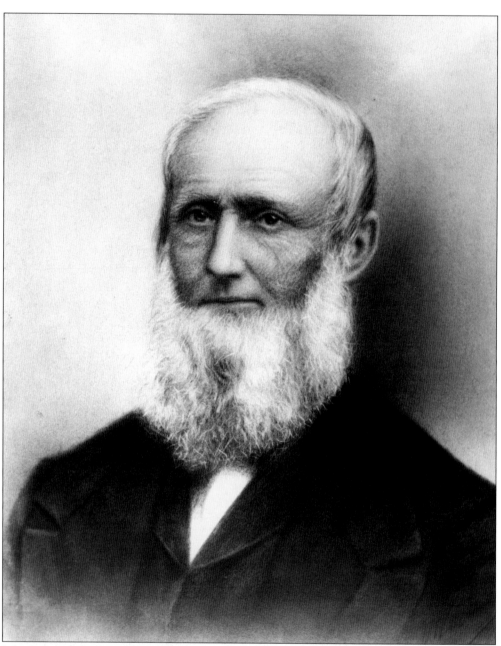

John B. Jervis, the namesake of Port Jervis, was one of the leading engineers of the 19th century. In 1825, at the age of 29, he became the chief assistant engineer of the Delaware and Hudson Canal. His training was on the Erie Canal, where he taught himself the logistics of engineering, like most of the American engineers in his day. His engineering skills were also instrumental in the construction of the Delaware and Hudson Gravity Railroad, and later on in his career he worked on the Erie Railroad, bringing it through Port Jervis. (Collection of the Minisink Valley Historical Society.)

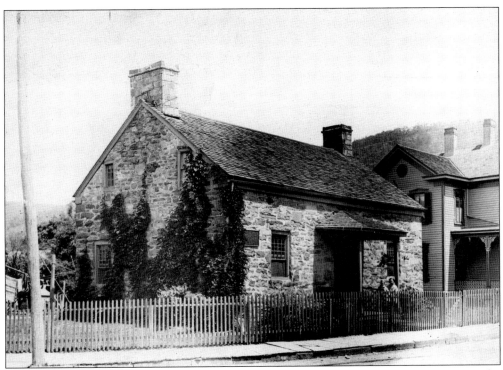

The Old Decker Stone House, also known as Fort Decker, was built c. 1760. During the construction of the canal, this hotel and tavern served as the headquarters for John B. Jervis. The fort is now the home of the Minisink Valley Historical Society on West Main Street in Port Jervis. (Robbie Smith.)

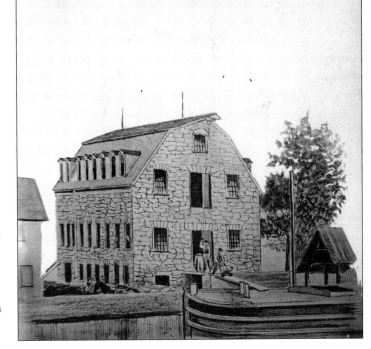

The surplus canal water turned the giant waterwheel of the Old Ball Stone Mill, which was erected in 1832. The building was located behind the Port Jervis Library on Pike Street and was destroyed by fire in the 1990s. (Collection of the Minisink Valley Historical Society.)

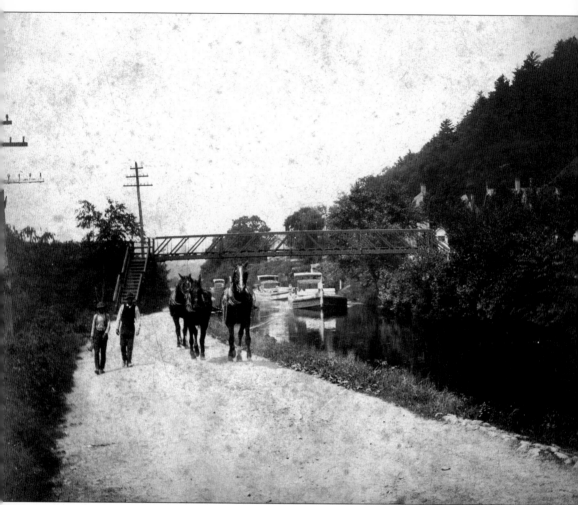

A single horse was all that was needed to pull early barges when the load was around 30 tons. As the canal enlarged and the loads increased in weight, the need for two or three mules became evident. The men seen in this c. 1885 photograph in Port Jervis had a long day ahead of them. They had to walk 15 to 20 miles a day and then tend the animals and pump out the boats for a mere $3 per month. (Robert Hartman.)

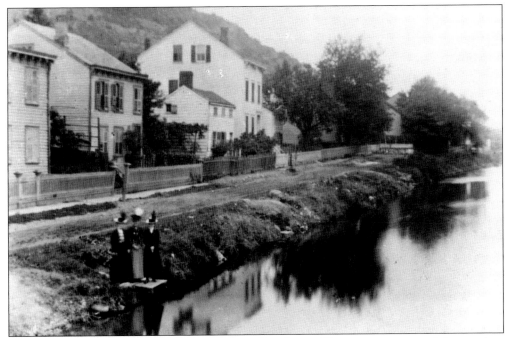

The canal passed through the center of town in Port Jervis. This area grew around the canal, as these houses on Grand View Avenue were built directly along its banks. This photograph was taken c. 1890s. (Collection of the Minisink Valley Historical Society.)

The canal in Port Jervis had a unique feature: water flowing in two directions. The West Basin brought the water down the Delaware River and from the East Basin via the Neversink River. This caused the canal company to install safety valves to contain the high water levels. One fed the mill while the other fed Clove Brook. Here, a light boat waits in the East Basin c. 1890. (Collection of the Minisink Valley Historical Society.)

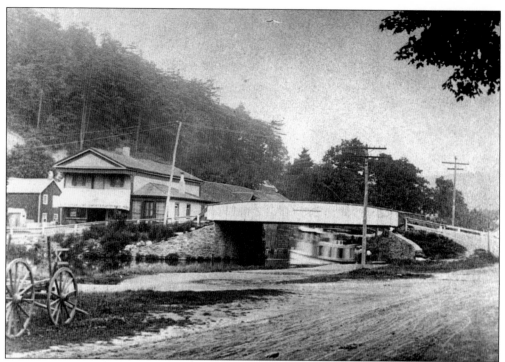

In Port Jervis, the Main Street Bridge is seen from the west side of the basin. The building to the left was the Delaware and Hudson Canal Company office. Coming up the canal is the paymaster's boat, which was the official boat used by the canal company and the only steam-powered launch on the canal. (Robbie Smith.)

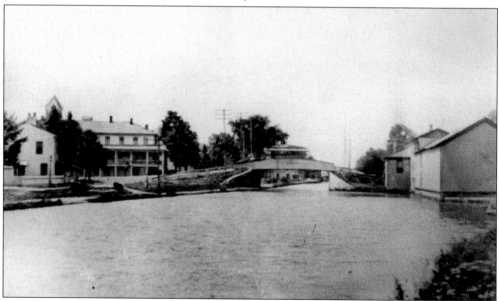

Shown here is the canal, as seen across the East Basin in the 1890s. The building on the left is the present-day Olde Canal Inn on West Main Street in Port Jervis. It is one of the oldest landmarks remaining from the canal era and was a very thriving business during the canal years. (Collection of the Minisink Valley Historical Society.)

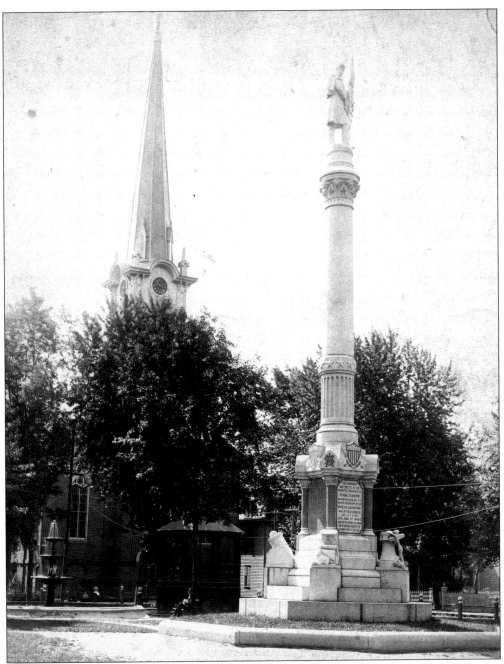

For many years, the Delaware and Hudson Canal Company earned extremely high profits. In the 1860s, its stock, valued at more than $200 per share, became one of the most sought after in the country. The towns that bordered the canal benefited greatly from the company's success in the form of donated property for churches, parks, and other community needs. In Port Jervis, the D & H provided the space for Orange Square Park, the Deerpark Dutch Reformed Church, and the original Drew Methodist Church on Hudson Street. This *c.* 1889 photograph of the park also shows the Civil War Monument, donated by Diana Farnum in memory of Civil War Veterans. (Robert Hartman.)

This c. 1880s photograph shows the Deerpark Dutch Reformed Church, whose property on East Main Street was donated by the canal company. The building to the right of the church was the canal office in Port Jervis. (Collection of the Minisink Valley Historical Society.)

When the canal closed in 1898, many of the bridges spanning it were either removed or lowered for highway use. This bridge on Orange Street in Port Jervis is shown in the process of being dismantled. (Robbie Smith.)

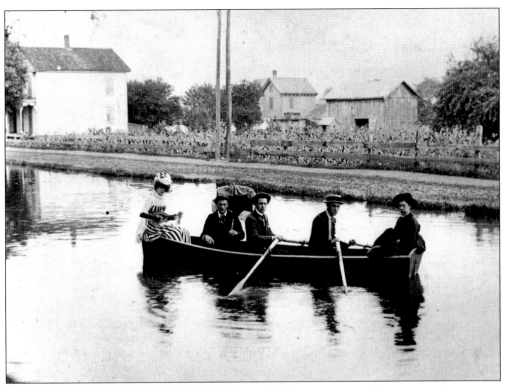

Even after the canal closed, it offered recreation for area citizens. This group relaxes on a rowboat ride near Port Jervis. (Robbie Smith.)

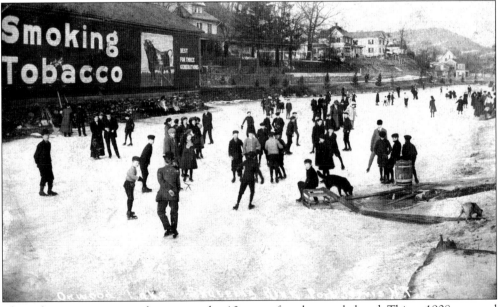

These skaters appreciate a clear winter day 10 years after the canal closed. This c. 1908 postcard shows the abandoned East Basin, then known as Onwood Lake. Certain sections of the canal held water for a few years until heath concerns forced them to be filled. (Collection of the Minisink Valley Historical Society.)

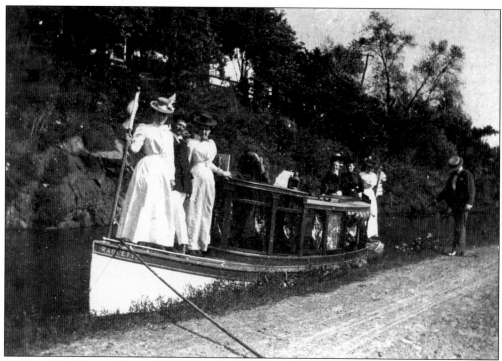

The canal, while mainly used for transporting coal, also served as a tourist attraction. By the 1870s, Port Jervis was a center for excursions. Many groups enjoyed visiting the scenic areas along the canal. (Robbie Smith.)

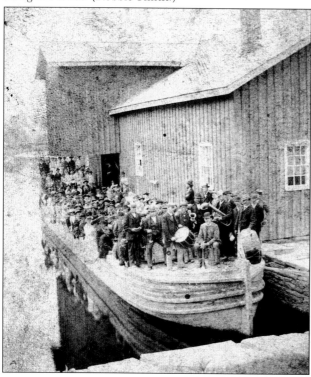

The canal was a favorite for Sunday school groups and tourists. In this *c.* 1880s Hensel view, a band gets ready for a grand ride. These groups would always be available to celebrate when new boats were christened. These celebrations took place from Honesdale to Rondout. This scene occurred at the Honesdale Basin. (Dave and Cyndi Wood.)

Shown here is a *c.* 1870s picturesque Hensel scene of Port Jervis's West Basin. The homes on Delaware Street were built on the edge of the canal; some still stand today. In the distance are the Old Stone Mill and the mountains of Matamoras, Pennsylvania. (Dave and Cyndi Wood.)

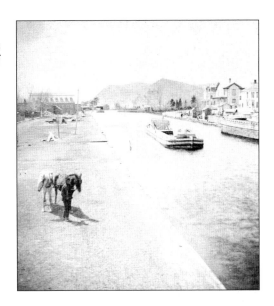

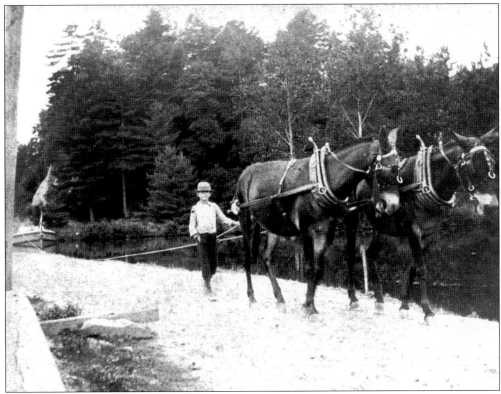

This is a classic Delaware and Hudson Canal photograph of a young boy leading his team down the tow path *c.* 1890. These boys, some all of 10 years old, had to work long, exhausting hours. Many captains of the boats began their career on the canal as drivers and then moved up the ranks. The canal company required that each boat have a crew of at least three members consisting of a captain, a bowman, and a driver. Often the driver, being young, was economically exploited and horribly treated. (Collection of the Minisink Valley Historical Society.)

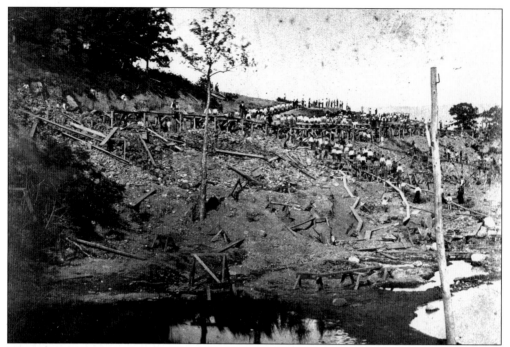

This c. 1869 image depicts the major canal break on the Port Jervis section of the canal. This break cost the company $12,000 and closed the canal for days. When breaks and wash-outs occurred, hundreds of men would be immediately employed to repair the damage. These types of disasters backed up the boats by the hundreds and cost the boat captains precious time. Since the canal only operated from April to November, time was money. (Robbie Smith.)

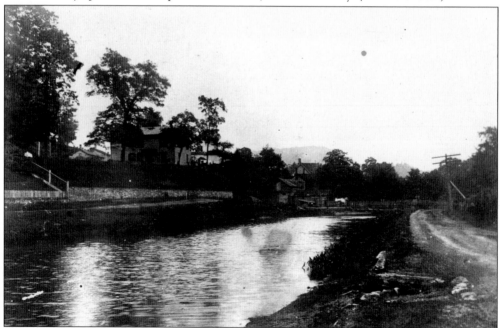

This c. 1890s view, taken from the West Basin, looks toward Orange Street in Port Jervis. The canal continued on the level section until it reached Lock 56 in Port Clinton. (Robbie Smith.)

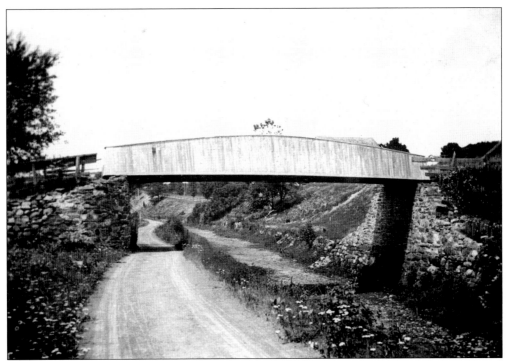

Shown *c.* 1900 is a typical canal bridge spanning the closed canal just east of the Hotel Huguenot. (Robbie Smith.)

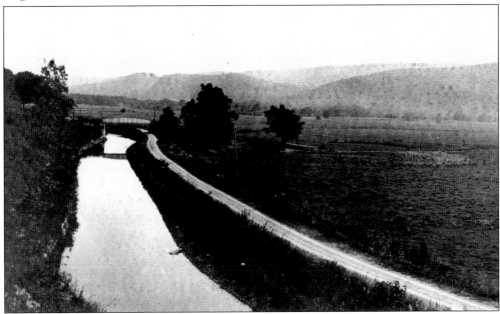

This view, facing east on the canal near Huguenot, looks so natural, filled with farm fields and mountains. The canal seems like it had been there forever. The area of Huguenot in the town of Deerpark was at one time larger than Port Jervis in population and importance. The Birdsall Boat Yard was located there, which was considered one of the best on the entire canal. (Robbie Smith.)

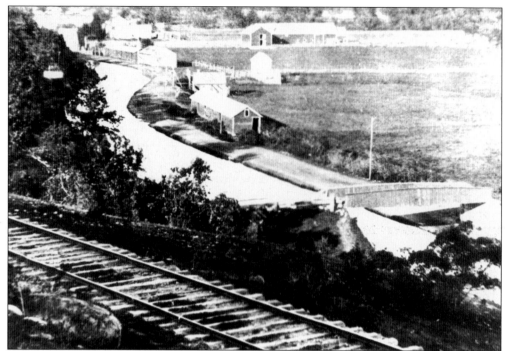

This c. 1890s photograph shows the canal and the Ontario and Western Railroad tracks near present-day Godeffroy, another section of Deerpark. The farm shown belonged to the family of Peter Gumaer, an early settler of Orange County, New York. (Collection of the Minisink Valley Historical Society.)

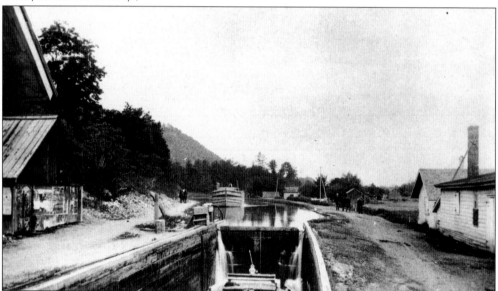

In Port Clinton, the first lock was reached after Hawk's Nest. This lock was most likely wood-lined with stone backing, while a few others were hand cut with fitted stone. This lock, No. 56 (also known as Mineral Springs), was the halfway point on the canal. It was 54 miles to Honesdale and to Kingston. Here, a loaded boat is in the lock while a light boat waits to go to Honesdale. (Robbie Smith.)

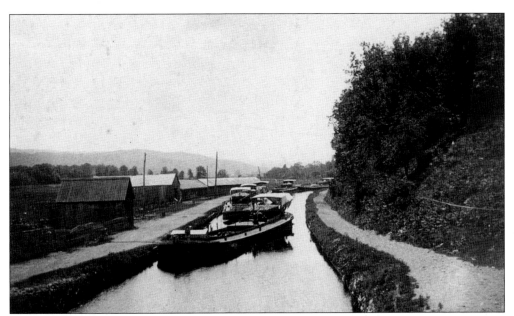

This scene in the 1890s shows six loaded boats on the Port Clinton section of the canal. The area is known as Godeffroy today. It was the birthplace of DeWitt Clinton, a former governor of New York who was also instrumental in the construction of the Erie and the Delaware and Hudson Canals. (Collection of the Minisink Valley Historical Society.)

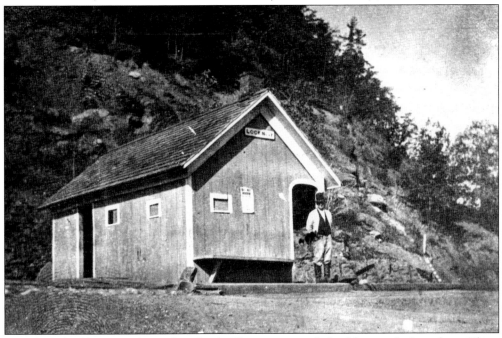

This lock building was located at Lock 52, just west of the Neversink Aqueduct. These buildings were usually of the same style and located beside the towpath for easy access to the canal. In this photograph is the lock keeper, whose job was to operate the lock and also to guard and inspect the canal. He was also expected to maintain a proper water level below his lock. (Collection of the Minisink Valley Historical Society.)

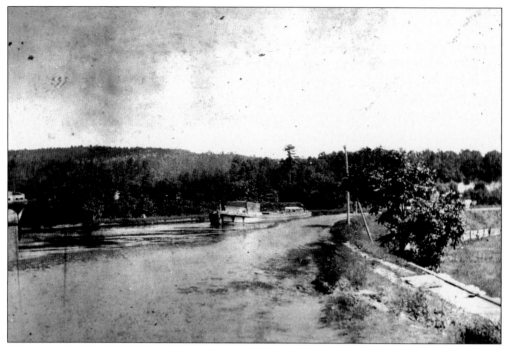

The captain of this loaded canal boat maneuvers his way along the canal. This image from the 1890s shows an area just west of the Neversink Aqueduct. While the canal covered 108 miles, 29 of those miles were on the level, and just west of this point began the 17-mile level to Summitville. (Collection of the Minisink Valley Historical Society.)

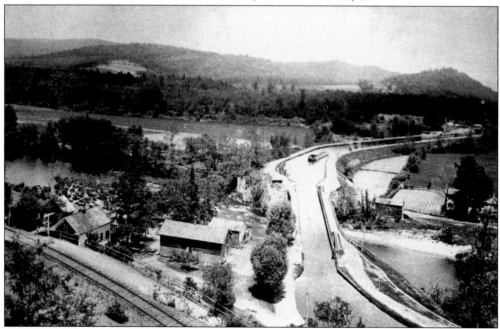

This *c.* 1880s view of the Neversink Aqueduct looks toward Cuddebackville. The area was known as Rose's Point, and the buildings to the right are now part of the Neversink Valley Area Museum. In the distance, loaded boats prepare to enter Lock 51. (Robbie Smith.)

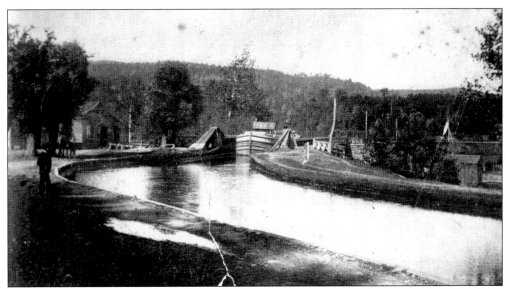

A light boat crosses over the Neversink Aqueduct during the twilight years of the canal. This structure, built during the 1847 expansion, replaced the original stone arch aqueduct that stood just downstream. This view was taken from the west side of the aqueduct. (Robbie Smith.)

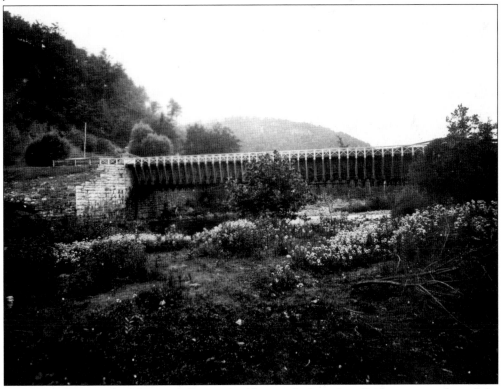

Constructed across the Neversink River, the Neversink Aqueduct Bridge was another of the Roebling designs. The third one built between Honesdale and Kingston for the D & H, this suspension-style bridge was completed at the start of the canal season in 1851. (Collection of the Minisink Valley Historical Society.)

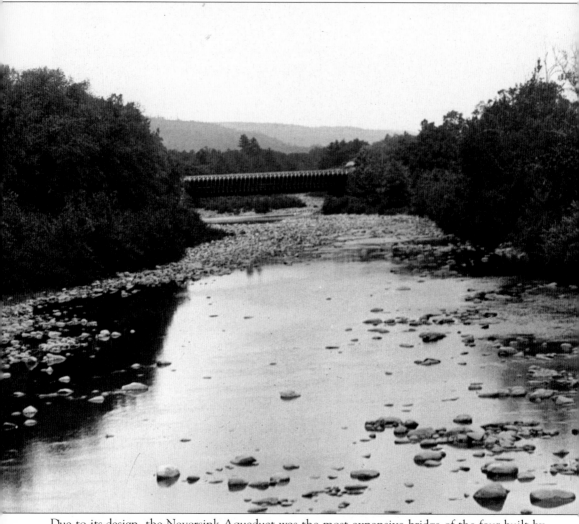

Due to its design, the Neversink Aqueduct was the most expensive bridge of the four built by Roebling. This 170-foot single-span used two 9.5-inch-thick cables, each weighing 36 tons. At the time, they were said to be the largest cables in the world used to suspend a bridge. (Robbie Smith.)

The canal had 16 feeders where water was diverted into it. This *c*. 1890s view shows the Neversink Dam and the building where intake gates were housed. These gates were used to control the height of the water in the canal. (Robbie Smith.)

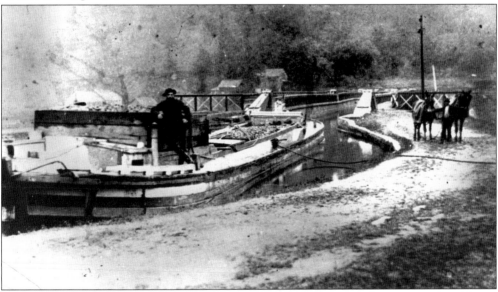

As the canal expanded in size, the boats grew larger. This increased the amount of coal being moved and provided competition for the railroad. The first boats, called "flickers," could haul 30 tons. These were followed by 40-, 50-, and, finally, 125-ton carriers. These large boats, in some cases, could navigate the Hudson River and reduce the expense of unloading at Rondout. This boat increased its capacity by being hipped. This meant raising boards on the side of the hold to carry more coal. Here, the captain leans against the hipped walls. (Collection of the Minisink Valley Historical Society.)

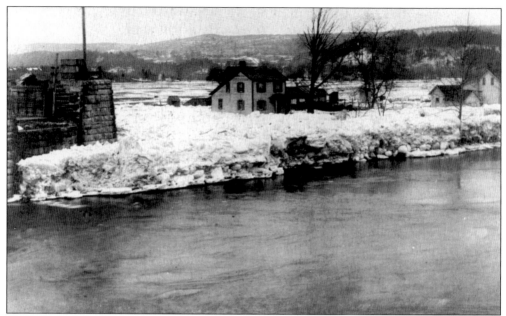

The Neversink Aqueduct, in use for 48 years, was abandoned in 1898 with the closing of the canal. The bridge had been dismantled and sold for scrap prior to the ice gorge of 1904 that had destroyed many other structures in the area on both the Neversink and Delaware Rivers. The abutments are all that remain of the aqueduct today. (Robbie Smith.)

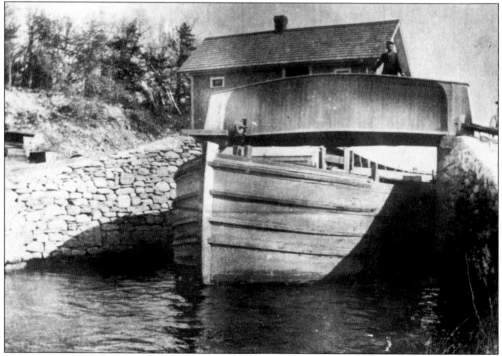

After crossing the Neversink Aqueduct, canalers entered Lock 51 in Cuddebackville. This lock was known as the "pie lock." Here, boaters would be treated to mouth-watering custard pies and bread baked by Mary Casey. (Collection of the Minisink Valley Historical Society.)

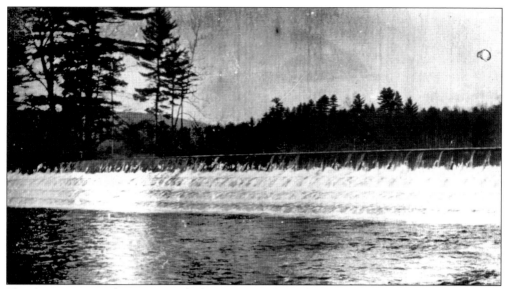

The large Neversink Dam was built upstream from the aqueduct. When the canal was constructed, it included such dams, located on many of the major water supplies of the canal. The half-mile feeder ditch provided water for the canal's 17-mile level area from Lock 51 east to Summitville. This photograph was taken *c.* 1890. (Collection of the Minisink Valley Historical Society.)

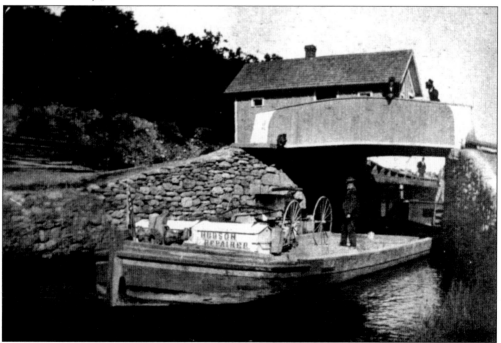

Lock 51, shown *c.* 1890, was operated by Abe Hoag. The locks numbered 51 through 55, known as the Neversink Locks, had special ropes known as Neversink Lock lines to get loaded boats up and over the Neversink River. This was the last lock for 17 miles east. A Delaware and Hudson Canal Company repair boat is seen exiting the lock. These boats patrolled the canal and handled general repairs and maintenance. (Collection of the Minisink Valley Historical Society.)

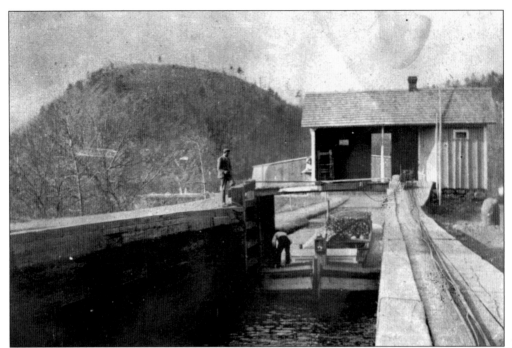

This *c.* 1890 view looks west through Abe Hoag's lock at Neversink. When the boating season ended (usually in November), the water in the canal was lowered. In the spring, any winter damage was repaired, the canal was refilled, and the boating season was begun. (Collection of the Minisink Valley Historical Society.)

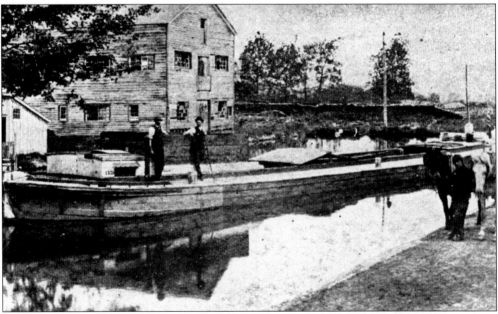

This horse driver leads his team along the towpath close to water's edge. The men and boys leading the animals were in constant danger of falling into the ditch along with the animals and drowning. This occurred usually due to exhaustion. (Collection of the Minisink Valley Historical Society.)

Lock tender Abe Hoag stands proudly with his best friend in 1890. The building in the rear is the mule barn in Cuddebackville. These barns sheltered the animals during the winter layoff, while the folks on the canal traveled home and waited for the next boating season. (Collection of the Minisink Valley Historical Society.)

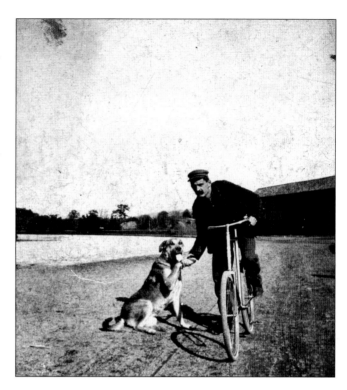

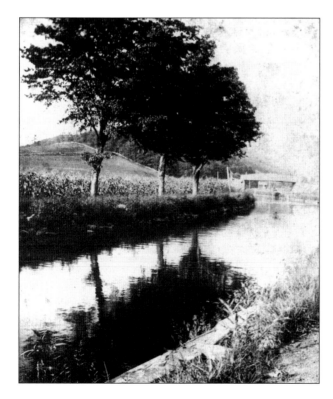

In Cuddebackville c. 1890s, the canal seemed to go on forever. Though the canal is famous as an engineering masterpiece, we cannot ignore its natural beauty. (Collection of the Minisink Valley Historical Society.)

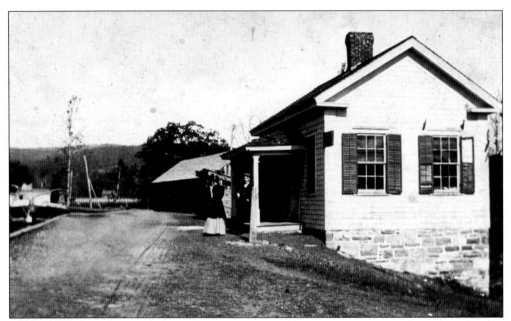

This telegraph office was near Lock 52 in Cuddebackville. The D & H was one of the first companies to run telegraph lines, helping to lead to the creation of the Western Union Telegraph Company. In 1848, those lines ran from Carbondale to Port Jervis and then along the Erie Railroad in Port Jervis. In April 1862, the New York state legislature allowed the D & H to run telegraph lines along the remaining sections of the canal to Kingston for company use. (Collection of the Minisink Valley Historical Society.)

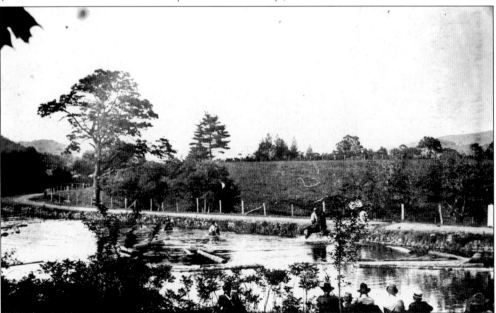

The canal found another use after its closing in 1898. In the early years of filmmaking, it served as a backdrop for films of notable directors like D.W. Griffith. He, along with legendary actors and actresses, would stay in Cuddebackville during the filming. This picture was taken *c.* 1912. (Collection of the Minisink Valley Historical Society.)

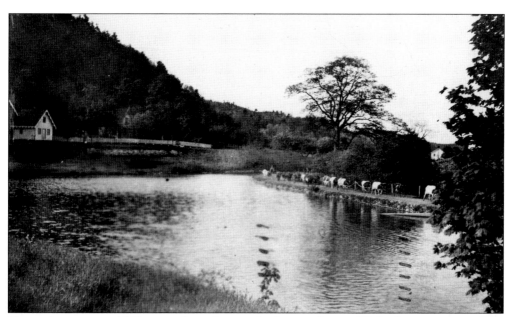

Shown here is a c. 1900 view along the canal after its closure. With the expansion of the railroad and its ability to operate year round, the canal became just another pretty picture. (Collection of the Minisink Valley Historical Society.)

This photograph, taken in the early 1870s, shows the Cuddebackville Basin. These types of basins were located in many areas so boats could stop. In between Neversink and Wurtsboro, there were at least six basins. In the vicinity, stores and taverns would develop in addition to boat repair shops. (Collection of the Minisink Valley Historical Society.)

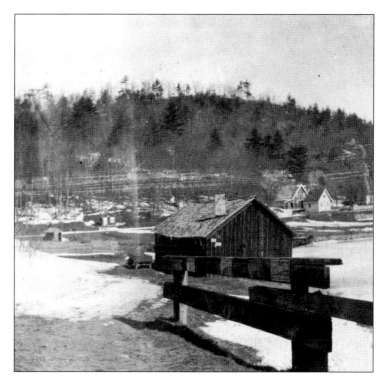

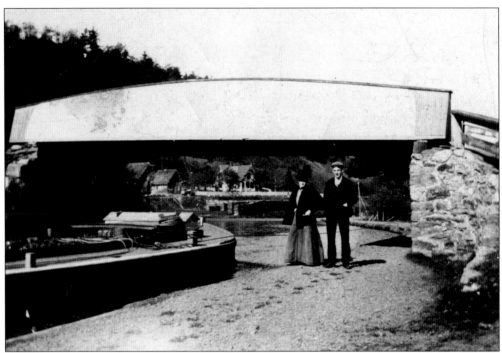

At the Cuddebackville Basin, this couple poses in their Sunday best c. 1890. The canal company was run by pious men; the entire operation closed on Sundays. Any person caught operating on the canal, including locks tenders, were fined and fired. (Collection of the Minisink Valley Historical Society.)

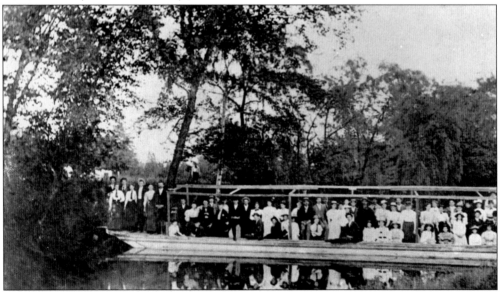

This church group enjoys a scenic ride on the canal in Cuddebackville. With Sunday as a day of rest and 17 miles of a lock-free canal, Sunday excursions on the canal were extremely popular. These enjoyable trips would take place on converted canal boats or special steam launches with nearly 60 people at a time boarding the boats. (Collection of the Minisink Valley Historical Society.)

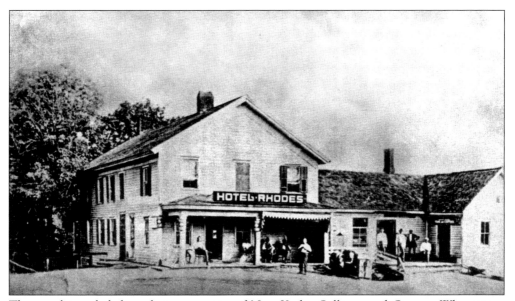

The canal traveled through two counties of New York—Sullivan and Orange. When it re-entered Sullivan County, the town of Westbrookville was its first stop. Shown here *c.* 1900 is the Hotel Rhodes, located directly on the towpath. (Collection of the Minisink Valley Historical Society.)

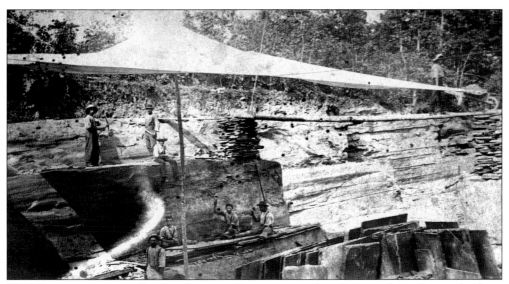

The bluestone quarrying developed as an industry at a number of points along the canal. Along the Delaware River in Pennsylvania and also in Westbrookville, New York, some of these extremely valuable mines could be found. This stone was shipped via the canal and used for sidewalks in New York, Philadelphia, and Havana, Cuba. This scene may be a mine located in Pennsylvania *c.* 1870. (Robbie Smith.)

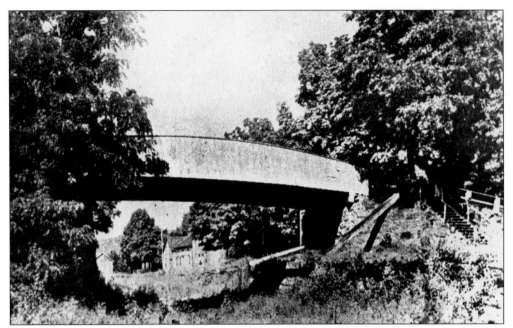

There were 136 highway bridges built along the canal in 1828. While some of these bridges served the community years after the canal's closure, most were torn down within a short period of time. This bridge, which spanned the canal at Sullivan Street in Wurtsboro, New York, was captured by the camera after its closure. (Collection of the Minisink Valley Historical Society.)

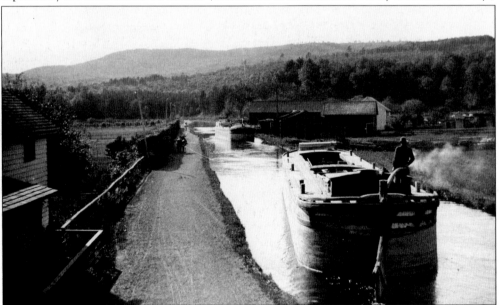

This *c.* 1893 scene shows light boats heading west from Wurtsboro. In the distance is the section of the canal called the Wurtsboro Turns. The boats at these bends needed to use special devices called whirling posts. The posts helped guide the boats and kept the lines of passing boats from tangling. When boats met on the curves, the light boats would pull to the berm side and let their lines sink. Loaded boats, on the other hand, would draw their line on the canal side of the post and pass. Note the large load of cord wood ready for shipment. (Robbie Smith.)

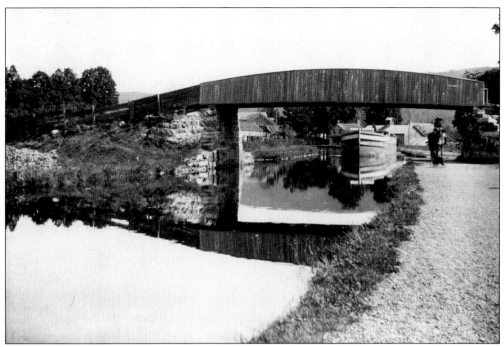

After navigating the Wurtsboro Turns, boats passed under the Sullivan Avenue Bridge and entered Wurtsboro, named after Maurice and William Wurts, founding fathers of the Delaware and Hudson Canal. This photograph was taken c. 1893. (Robbie Smith.)

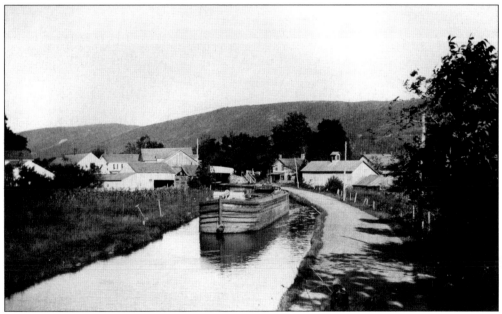

In this c. 1893 Wurtsboro scene, a young girl leads her team along the towpath back to Honesdale. The running of most canal boats prior to the Civil War was done by men and boys. However, after the war the entire family began working on the boats. In Wurtsboro, the canal crossed the Newburgh Cochecton Turnpike, which was instrumental in the development of Sullivan County, New York. (Robbie Smith.)

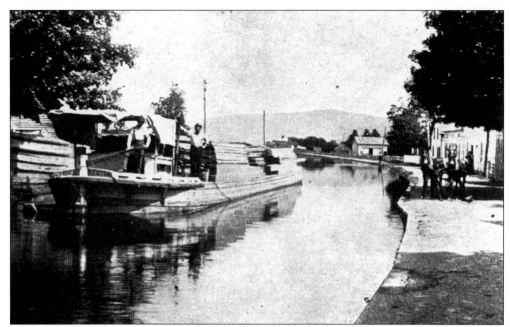

The shipping of wood along the canal was a major industry. Whether the wood was cut into lumber for boat builders or cord for heating, the product traveled the canal continually. Since the Delaware and Hudson Canal Company owned most of the forest property adjacent to the canal, it controlled the wood-shipping industry. (Collection of the Minisink Valley Historical Society.)

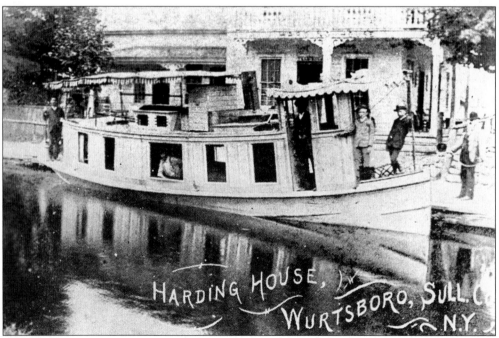

The Harding House, located in Wurtsboro, is seen in this c. 1900 postcard. This tavern was a popular destination for thirsty boatmen. The building stood so close to the canal that when the front door opened it could hit the drivers; hence, it became a convenient stop. (Robbie Smith.)

Five

SUMMITVILLE TO RONDOUT

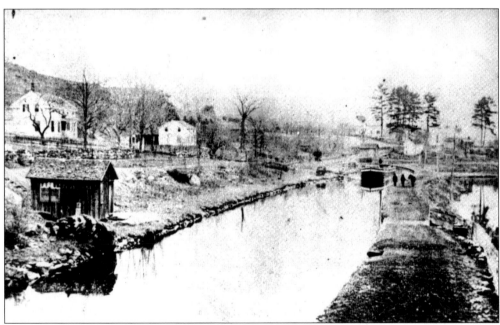

Shown here is Summitville in the 1890s, the highest point on the New York section of the canal. The 17-mile level from Neversink ended here, and the canal began its descent to the Hudson. On July 13, 1825, the Delaware and Hudson Canal began its mark on local and national history. It was to become one of the strongest corporations in the 19th century and would be heralded as the first million-dollar-capitalized company. Phillip Hone turned the first shovel of earth in the Summitville region. The construction of the canal employed 2,500 men each season and, incredibly, three years later the first boats completed the 108-mile trip from Honesdale to Kingston. (Collection of the Minisink Valley Historical Society.)

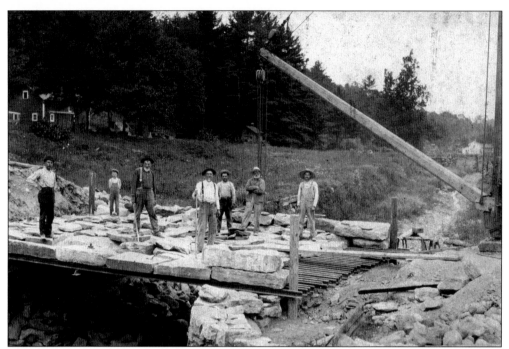

When the announcement came that the canal would close after the 1898 season, waste weirs were opened and the water was drained. The bridges that spanned it were lowered and, in time, new bridges were added. This *c.* 1904 photograph shows a new highway bridge being built in the Summitville region of the canal. Canal life by this time had ended, and the Wurts Ditch was just a memory. (Collection of the Minisink Valley Historical Society.)

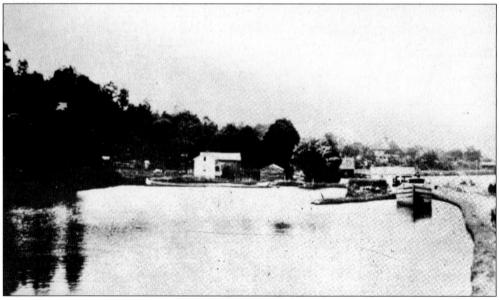

In Phillipsport, the slow descent began to the Hudson River. The canal boats went through 50 locks and dropped approximately 500 feet before entering the tidewater at Eddyville. This *c.* 1890s view faces north, showing a light boat heading toward the summit. (Collection of the Minisink Valley Historical Society.)

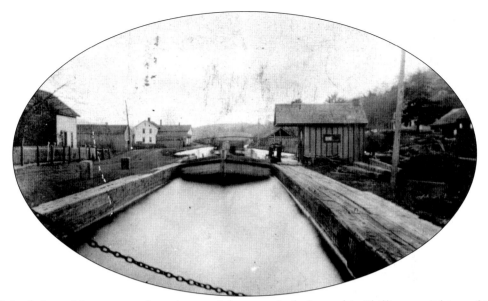

A loaded canal boat comes through one of the many locks located in Phillipsport. This card is dated 1908, 10 years after the canal closed, but when there was still interest in reopening the Ditch. As late as 1915, a final attempt was made at Honesdale to revive the Ditch; it duly failed. (Collection of the Minisink Valley Historical Society.)

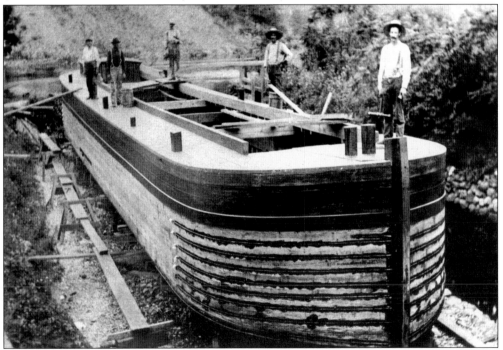

A canal boat is under construction at the Boothroyd Dry Dock in Phillipsport. The construction of canal boats was a major industry. In the 1850s, each boat cost between $400 and $450 to construct, with a service span of five years. The boat designs changed over the years, with oak always being the main wood of choice. (Collection of the Minisink Valley Historical Society.)

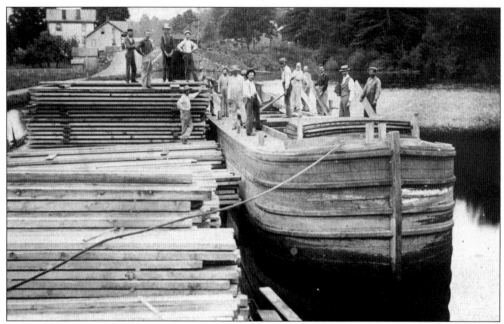

The workmen at Rose's Basin are busy stacking lumber in this *c.* 1880s photograph. The trees needed for boat construction were usually cut in the hills bordering the canal and led, in many cases, to clear-cutting of the hillsides. The growth of Phillipsport was based mainly on boat building. It was home to four major boat builders: W.B. Snyder, Charles Medler, Russell and Baker, and the Caldwell Brothers. (Collection of the Minisink Valley Historical Society.)

Along the canal just west of Ellenville was Lock 32. In this *c.* 1890s photograph, lock tender Sam Taylor sits, waiting for the next boat to enter the lock. By the 1890s, traffic on the canal had slowed drastically, and it was only a matter of time before Sam would be out of a job. Today, the Nevelle Country Club occupies this area of the canal. (Collection of the Minisink Valley Historical Society.)

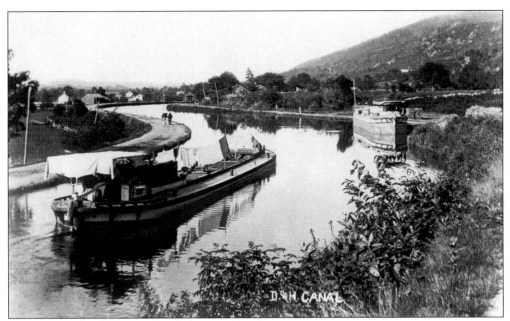

This view shows the area just west of Ellenville after entering Ulster County. It was the next major section on the canal that the boats entered after Phillipsport. This loaded boat, with all its laundry drying, heads west toward Rondout *c*. 1890. (Robbie Smith.)

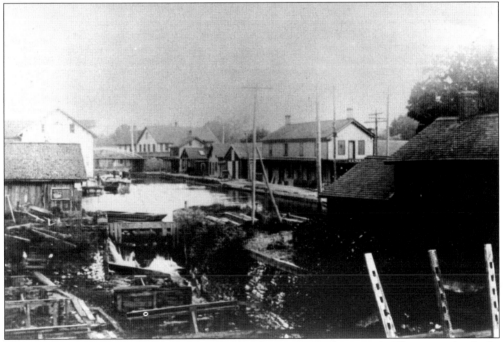

A view of the dry docks in Ellenville is seen in this *c*. 1890s photograph. The many dry docks up and down the canal were needed for the construction and maintenance of the boats. This photograph shows the upper gate of the dock where the boat would enter; the lower gate would then open and release the water, and the boat would rest on the docks. The racks in the lower left would hold the boats while workmen performed repairs. (Robbie Smith.)

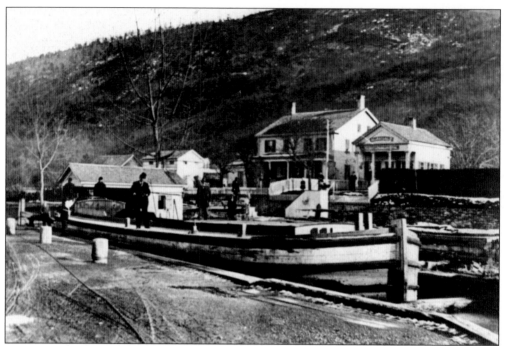

There were three locks in Ellenville, each with a lift of 10 feet. This boat pauses in front of Lock 31 *c.* 1890. The small building on the right is the Delaware and Hudson Canal Company office. (Robbie Smith.)

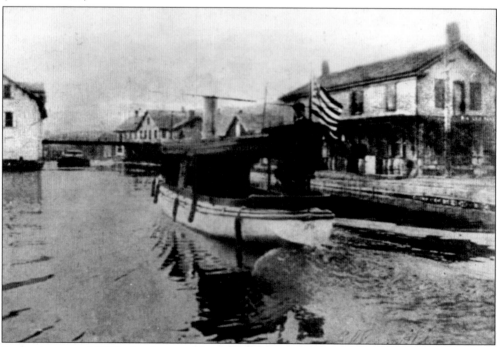

In the summer of 1898, the chartered launch *D & H* steamed up the entire canal. During that tour, a photographer rode along and recorded the final scenes of the canal's operation. Here, the *D & H* cruises through Ellenville and heads north. (Robbie Smith.)

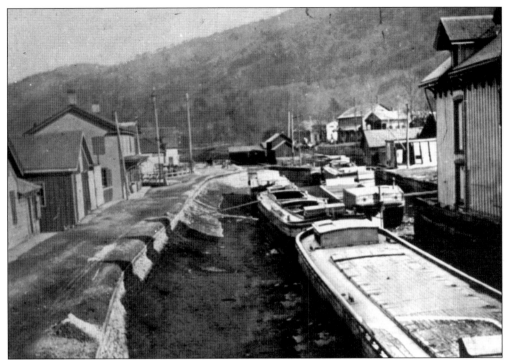

These boats lie idle on the bottom of the Ellenville Basin. When the canal closed in 1898, all equipment was moved from Honesdale to Rondout. It was then drained off west of Ellenville to Honesdale. The canal continued to operate for two years from Ellenville and for five years from High Falls to Tidewater. (Robbie Smith.)

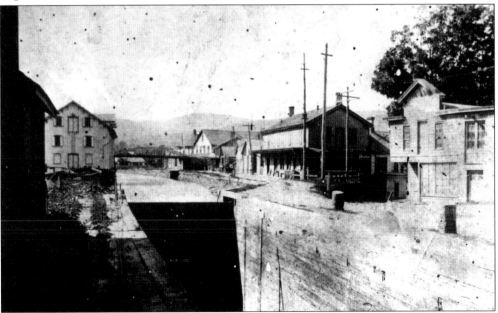

With the snubbing posts still in place, all is quiet in this post–canal era picture. After the closing of the canal, the many businesses that depended on the canal for their survival failed and faded into history. Seen here is an empty Lock 31 in Ellenville. (Robbie Smith.)

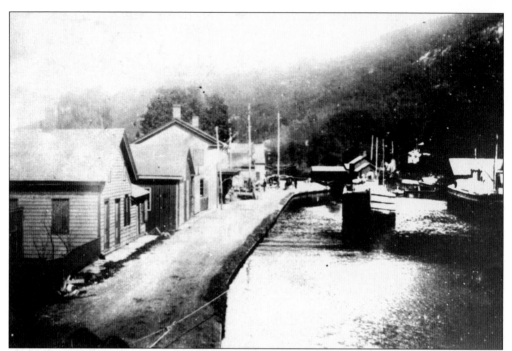

When this picture was taken in the late 1890s, the canal's fate had already been sealed. The railroad was completely in control of transporting coal. The number of trips on the canal for a single boat was seven, and only 250 boats operated. In the 1870s, by contrast, more than 1,000 boats made 13 trips annually and hundreds reached Kingston weekly. (Robbie Smith.)

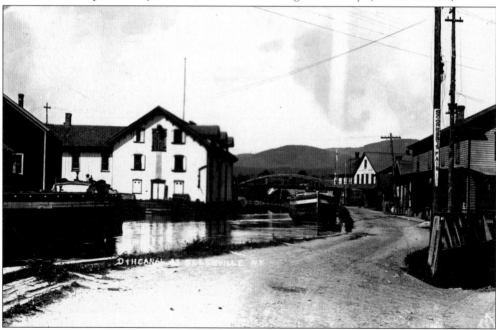

The canal passed the warehouses of the Merchant Tanners Line in Ellenville. This company operated six large freight boats that moved local goods to New York City. The Center Street Bridge is in the foreground. (Robbie Smith.)

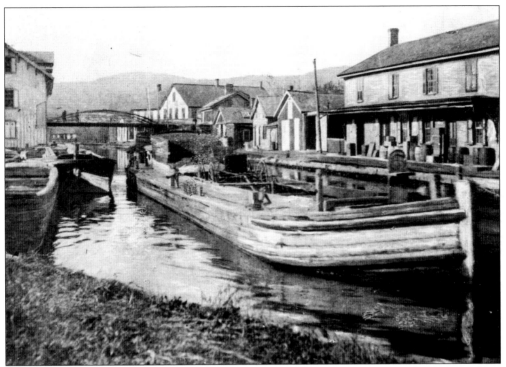

With his wagon on board, the captain of this canal boat makes his last trip of the season. When he reaches Rondout, he will dock his boat for the winter, ride home, and later ready himself for next season. (Robbie Smith.)

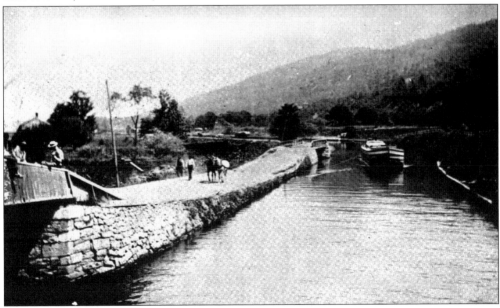

This scene in Ellenville reveals a group fishing from the Glass Company Bridge. The fishing in the canal was described as some of the best in the area. Feeders from major streams released large amounts of pike, pickerel, and perch to swim in the canal. (Collection of the Minisink Valley Historical Society.)

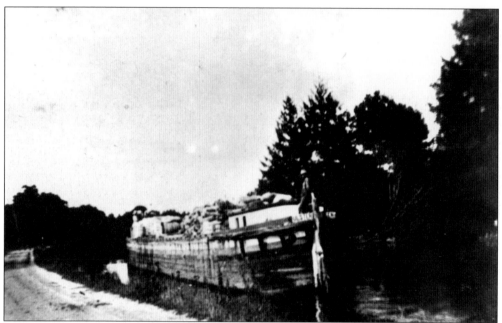

The freight boat *Ulster Queen*, operated by the Hunt and Donaldson Company of Ellenville, was 90 feet long and hauled many types of products. These freight boats, though a small percentage of the 915 boats that traveled the canal in the 1880s, were a very important part of the local economy. These were some of the last boats to run the canal between Ellenville and Kingston. (Collection of the Minisink Valley Historical Society.)

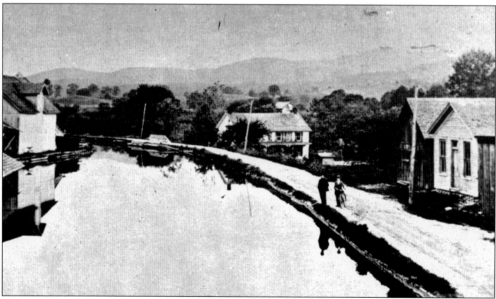

The Ellenville section of the canal near Center Street is seen in this c. 1880 photograph, which gives a southerly view. This area, as well as many other locations along the canal, was a favorite swimming hole. While the canal owners did not approve of this summertime activity, area children continued to take dips. The roof on the far left was used as a slide to ride into the pool of water. (Collection of the Minisink Valley Historical Society.)

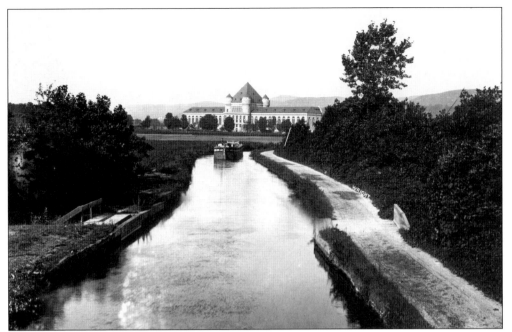

The last canal boat to run the entire canal in 1898 can be seen passing by the Eastern Correctional Institution in Napanoch, New York. This penal institution was built during the life of the canal, and much of the material used in construction was shipped along the Delaware and Hudson Canal. (Robbie Smith.)

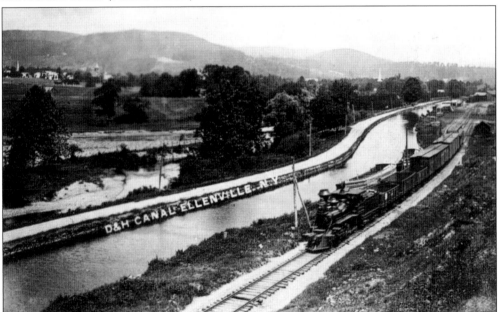

The town of Ellenville can be seen in the distance in this 19th-century photograph. The New York, Ontario, and Western Railroad ran parallel with the canal at this point along its course. The canal and railroad workers were always at odds, and many fights occurred. The railroaders were notorious for blowing their whistles when nearing the canal and scaring both drivers and teams into the water. (Collection of the Minisink Valley Historical Society.)

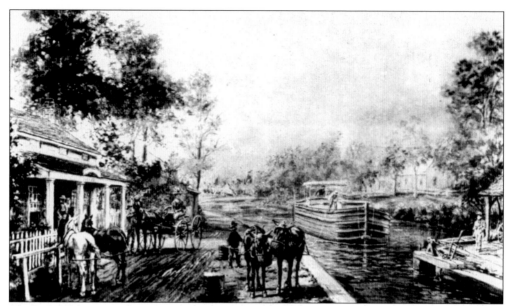

The beautiful scenes along the canal were favorites for many artists of the 19th century. The earliest painting was created by James Smile in 1839, with many others following his love of the Delaware and Hudson. The most notable artist was Edward Lamson Henry (1841–1919), whose paintings along the canal gained considerable recognition. (Robbie Smith.)

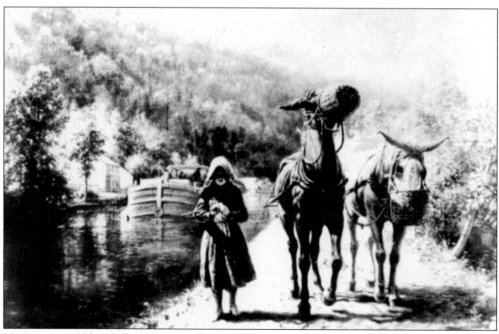

Henry practiced his skills as an artist during the waning years of the canal. His fascination with the canal is evident in his sketchbook of images, *Canal Studies*. (Robbie Smith.)

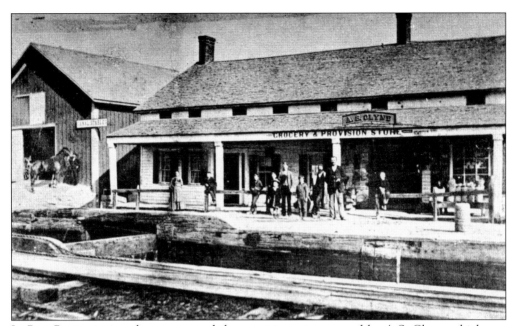

In Port Benjamin was the grocery and the provisions store owned by A.S. Clyne, which was located at Lock 26. This area is known today as Warwarsing, New York. (Collection of the Minisink Valley Historical Society.)

The snubbing post was as common as the trees up and down the canal. These granite posts were used at locks to tie the boats off so as to keep them from hitting and clanging the side of the locks. They were also located at the basins where the boats would be tied up for the night. (Robbie Smith.)

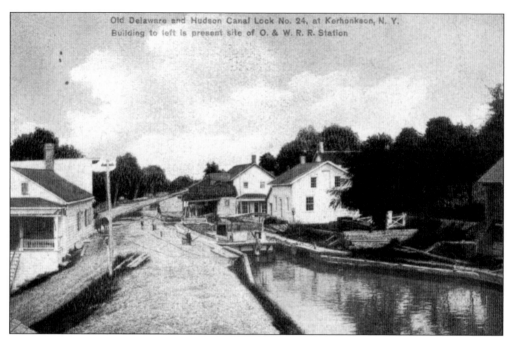

Originally, this section of the canal was called Middleport, but today we know it as Kerhonkson. This *c.* 1890s view shows a loaded boat snubbed in at Lock 24, which was 20 miles east of Rondout. The crew waits for the upper gate to be raised so they can continue. (Robbie Smith.)

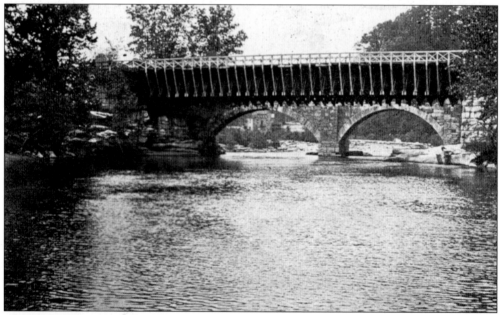

The High Falls Aqueduct, built during the mid-19th-century expansion of the canal, was abandoned in 1898. Like all the aqueducts except the Delaware (which became a highway bridge), it stood derelict for years. This aqueduct burned in 1916 and, today, only the abutments remain. (Collection of the Minisink Valley Historical Society.)

112

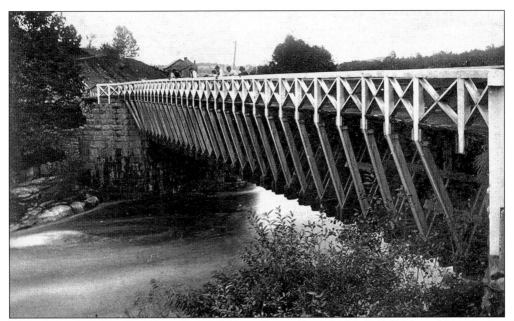

This *c.* 1870s Edward Anthony view depicts the single-span High Falls Aqueduct crossing the Rondout Creek. This was the only aqueduct not named after the water it spanned. The fourth of Roebling's suspension bridges for the Delaware and Hudson Canal, it opened in 1851 at a cost of $20,400. It replaced the old stone arch aqueduct that stood nearby. (Dave and Cyndi Wood.)

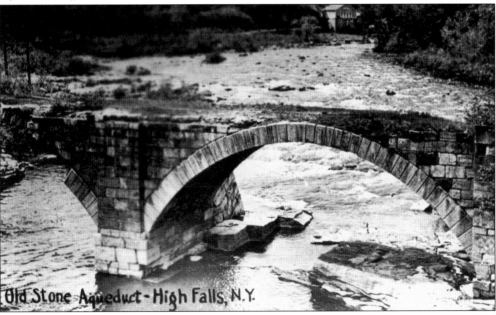

Shown here is the original stone arch aqueduct as it looked in the 20th century. Constructed in 1828 across the Rondout Creek, it served the canal for 20 years. In 1847, when the canal was expanded, this structure could not be widened; thus, the Roebling Bridge was built. This arch withstood the test of time and was eventually demolished in the mid-20th-century using dynamite. (Collection of the Minisink Valley Historical Society.)

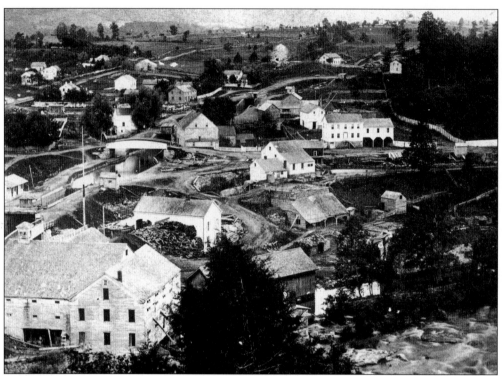

In High Falls, the canal traveled through nine locks, numbered 20 through 12, dropping 90 feet in a very short span. These locks were not wood-lined like the others. They were made of hand-cut stone to fit. In this early view of the town, Locks 15, 16, and 17 can be seen. (Robbie Smith.)

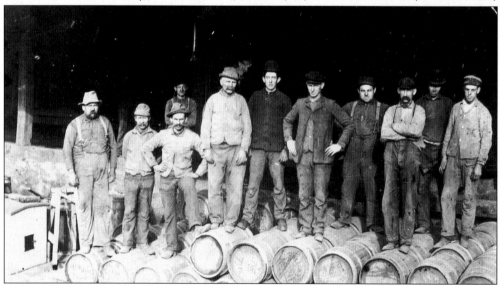

The canal opened up a large market for the high-quality Rosenberg Cement. Used on the Croton Waterway and the base of the Statue of Liberty, this product was so popular that, by 1866, nearly 75,000 tons per year were shipped down the canal. In this *c.* 1885 photograph, Lawrenceville workers pose with its next shipment. (Collection of the Minisink Valley Historical Society.)

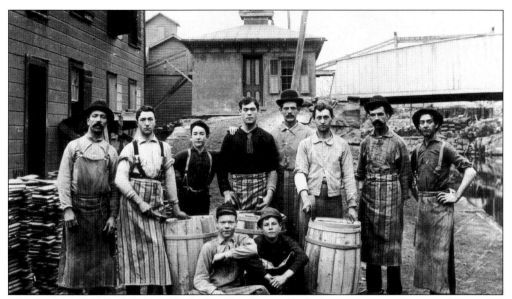

The cement and canal business had a huge impact on the Ulster County economy. The cement factories employed many people such as kilnsmen who processed the cement, and coopers who constructed the barrels for shipping. These coopers stop for a pose at the Lawrenceville Cement Factory *c.* 1885. The canal is seen to the right. (Collection of the Minisink Valley Historical Society.)

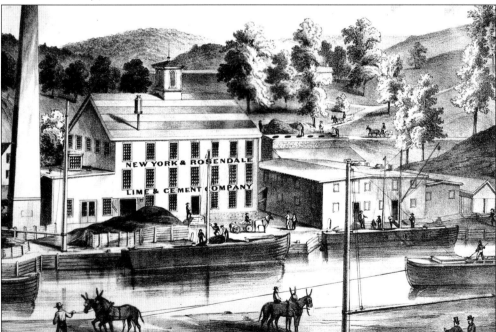

This is an early lithograph of the New York and Rosendale Lime Cement Company in Rosendale. In 1826, hydraulic limestones of superior quality was discovered in Rosendale. This cement was used in the construction of the locks and aqueducts all along the canal. Prior to this discovery, the cement was being shipped in from distant points. (Collection of the Minisink Valley Historical Society.)

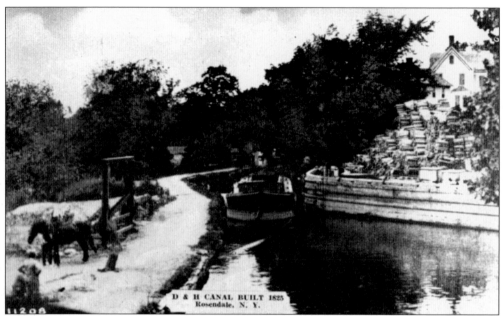

The canal from Rosendale to Rondout continued to operate five years after the official closure in 1898. The cement companies found the canal still to be a useful means by which to move their products. This scene from the 1890s is taken in the Rosendale section of the canal. (Robbie Smith.)

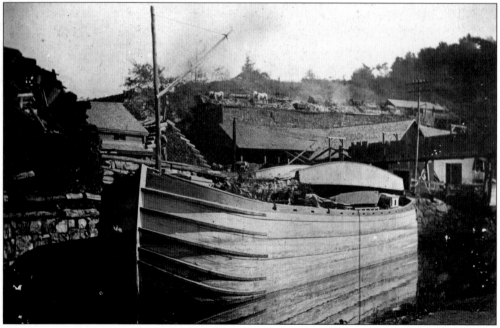

When cement rock was discovered in the Rosendale area, factories opened up for business immediately. This canal boat, owned by A.J. Snyder and Sons Cement Company, could carry 1,000 barrels of cement to Rondout, where it was shipped to ports all along the Atlantic seaboard. In the background, the quarrying operation where the cement was processed can be seen. (Robbie Smith.)

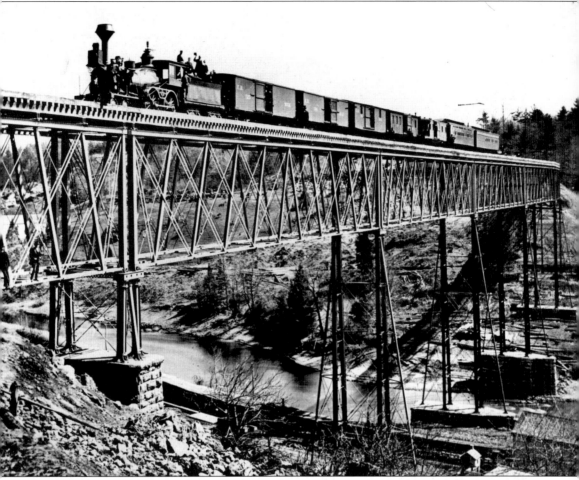

In 1828, the canal became the major form of transportation for products in this region. It replaced the wagons that used the Owego Turnpike and Old Mine Road, thereby replacing this country's major transportation system of the previous 100 years. In 1898, 70 years later, we see the closure of the canal, replaced by the Iron Horse. The railroad that the D & H introduced led to the canal's demise. Within the next 70 years, we witness the slow erosion of the railroad and we revert back to wagons, although now they are tractor trailers. I wonder if, in the year of 2040, we will revert back to canals. When this photograph was taken in 1876, the 140-foot-high Wallkill Valley Viaduct had been recently completed. It was located near Rosendale, and the Delaware and Hudson Canal lay in its shadow. (Robbie Smith.)

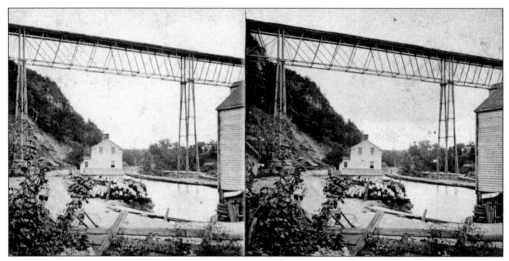

This *c.* 1870s Auchmoody stereo view shows the huge Wallkill Viaduct that spanned the Rondout Creek. This railroad bridge, though abandoned, still stands today as an observation deck. This view was taken from Lock 7. (Dave and Cyndi Wood.)

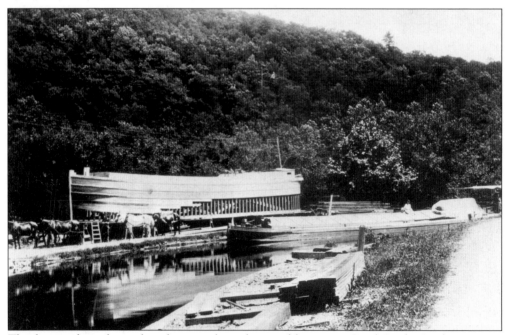

This boatyard was located in the area along the canal known as Creek Locks. In this section, the boats passed from the man-made canal to the slack water of Rondout Creek. The navigation on this two-mile section was tricky due to the current of the stream. This photograph was taken *c.* 1890. (Robbie Smith.)

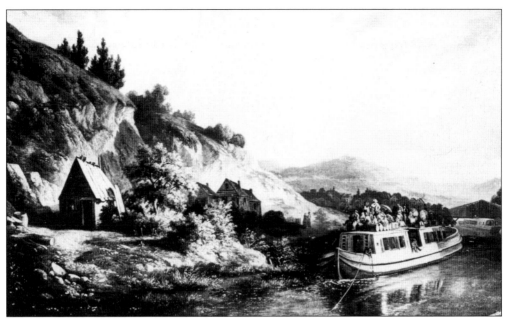

A packet boat glides along the canal in this artist's rendition. These passenger vessels traveled on the canal mainly in the early years. They were handsomely furnished and ones like the *Fashion*, built in 1850, were very large, having a dining area and sleeping quarters for 100 people. The *Fashion*, though, saw a quick demise. On the night of April 25, 1851, it burned to the water line in the Honesdale Basin, as did a section of Honesdale. This tragedy ended the use of the packet boat on the Delaware and Hudson Canal for the most part. (Robbie Smith.)

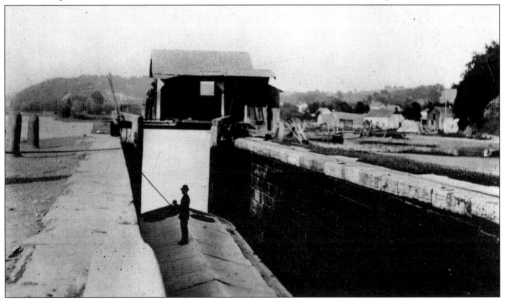

This cement barge has just exited the weigh lock and is now proceeding through the last lock on the 108-mile canal. This tidewater lock was located in Eddyville, New York. Here, the exiting boats went from the slack water of the Rondout directly into the creek, the tidewater of the Hudson River. The journey was complete. Just ahead lay the canal company docks at Rondout. (Collection of the Minisink Valley Historical Society.)

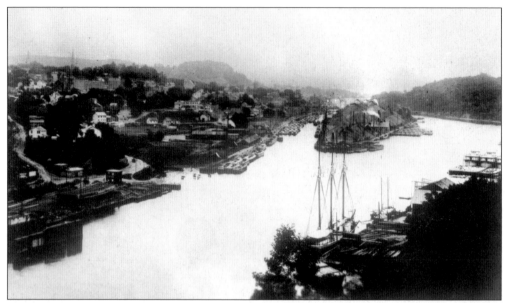

The final destination was Rondout, just west of the confluence of Rondout Creek and the Hudson River. In this *c.* 1890 photograph, the boats are lined up near the Island Docks waiting to be unloaded. The mountain of coal stored at Rondout was colossal; at times nearly 100,000 tons were stockpiled and waiting for shipment. (Collection of the Minisink Valley Historical Society.)

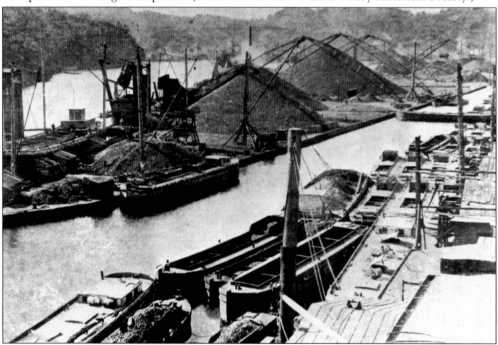

The coal docks in Rondout were constructed directly in the center of the creek on a man-made island in 1848. In the early years, when the coal was unloaded by hand, it would take three men eight hours to shovel 125 tons. This was hard labor and was not efficient. In later years, steam-operated elevators were introduced, quickening the process. (Collection of the Minisink Valley Historical Society.)

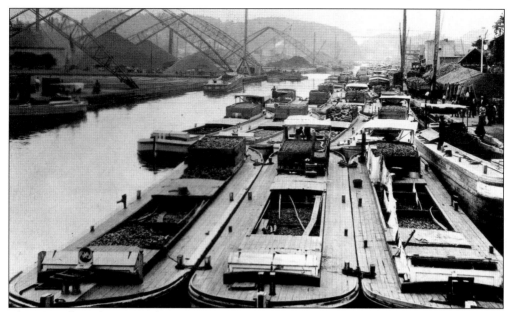

The 1890s brought to Rondout a new way of loading and unloading the barges. The Dodge Yarding System elevators seen in this photograph could unload and pile coal at 1,000 tons per day and, when reloading, could size and weigh at the same time. This new innovative machinery, while upsetting to workers due to layoffs, improved productivity. Though the sun was already setting on the overall feasibility of the canal, the Delaware and Hudson Canal Company was still continuing to operate its business efficiently. (Collection of the Minisink Valley Historical Society.)

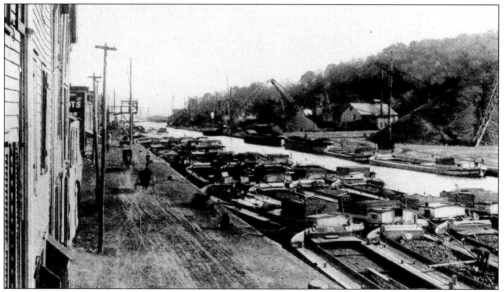

This c. 1890s view along the canal front faces the Hudson River in Rondout. The town of Rondout was a busy place, like Honesdale on the western end of the canal, with most residents being employed by the D & H. In the 1850s, its population was almost double that of Kingston, which at one time was the capital of New York. (Collection of the Minisink Valley Historical Society.)

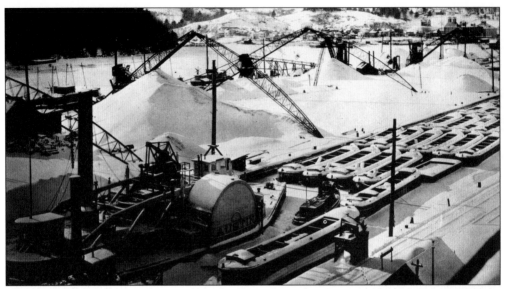

The coal-shipping business came to a halt when winter set in at the Rondout terminal. Like Honesdale in the western end of the canal, huge mounds of coal would sit until the waterway thawed out for the spring season. This photograph was taken *c.* 1890. (Collection of the Minisink Valley Historical Society.)

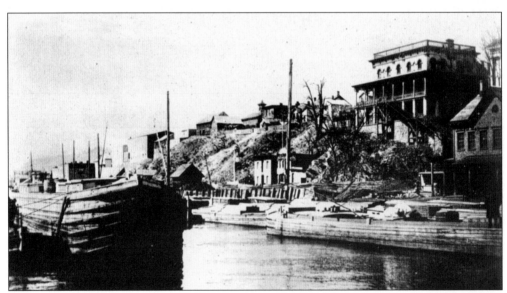

Like so many other towns along the 108-mile ditch, the port at Rondout was created by the Delaware and Hudson Canal Company. The large building to the right was the canal company main office, which stood proudly overlooking its huge operation. (Collection of the Minisink Valley Historical Society.)

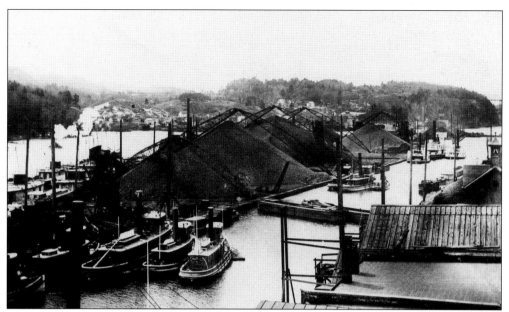

The tugboats wait to bring barges down the Hudson River to New York City *c.* 1890s. While most coal boats were unloaded here and their cargo reloaded on river barges, some of the canal boats could navigate the Hudson with the aid of a tugboat. (Collection of the Minisink Valley Historical Society.)

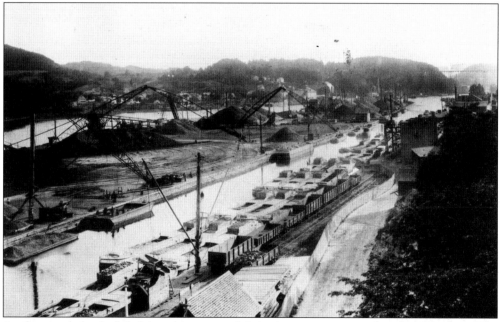

As the canal slowly faded into history, so did the huge mountains of coal at Rondout. The Delaware and Hudson Canal Company provided a great service to the industrial revolution in this country. It was one of the major companies that made the coal industry one of the most profitable businesses of the 19th century. The D & H paved the way for what was to come in the next century, helping coal to play an important part in our country's development as a superpower. (Collection of the Minisink Valley Historical Society.)

THE DELAWARE & HUD

CANAL

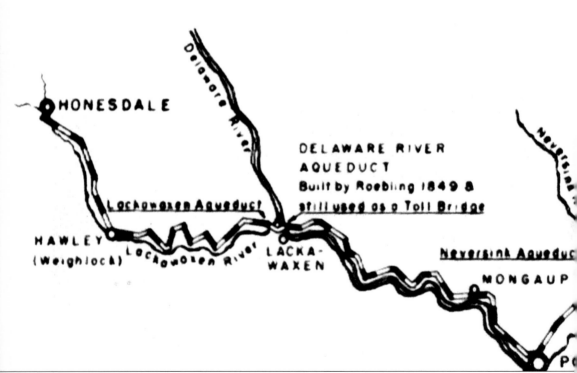

HONESDALE

Delaware River

DELAWARE RIVER
AQUEDUCT
Built by Roebling 1849 &
still used as a Toll Bridge

Lackawaxen Aqueduct

HAWLEY
(Weighlock)

Lackawaxen River

LACKA-
WAXEN

Neversink Aqueduct

MONGAUP

This map of the Delaware and Hudson Canal shows its course through two states and five counties. It developed areas like Honesdale, Pennsylvania, and Port Jervis and Rondout, New York, into large regional economic centers. In 1828, when the canal was completed, it was an engineering marvel. By 1880, the canal company was a huge corporation employing thousands, and the canal consisted of 107 locks, 2 weigh locks, 2 stop locks, 2 guard locks, 18 wooden trunk

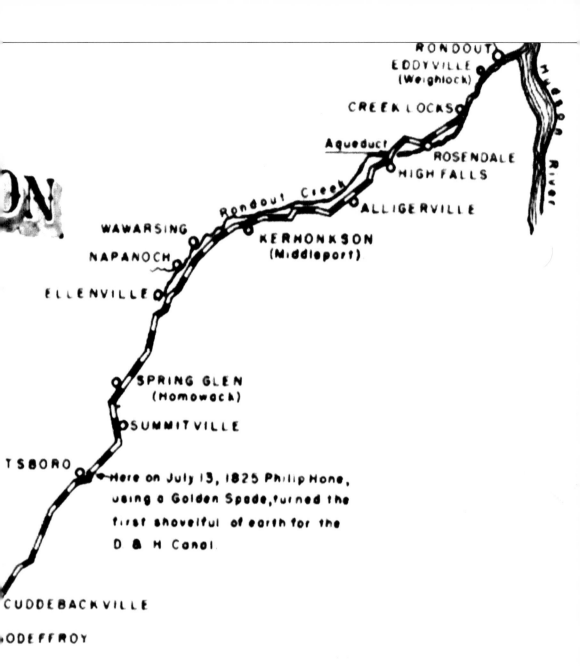

ON

RONDOUT
EDDYVILLE
(Weighlock)

CREEK LOCKS

Aqueduct

ROSENDALE
HIGH FALLS

Rondout Creek

ALLIGERVILLE

WAWARSING
KERHONKSON
(Middleport)

NAPANOCH

ELLENVILLE

SPRING GLEN
(Homowock)

SUMMITVILLE

TSBORO

Here on July 13, 1825 Philip Hone, using a Golden Spade, turned the first shovelful of earth for the D. & H. Canal.

CUDDEBACKVILLE

ODEFFROY

ERVIS

aqueducts, 4 suspension aqueducts, 110 waste weirs, 14 canal feeders, 16 feeder dams, 136 highway bridges, 37 towpath bridges, 22 reservoirs, 915 canal boats, 66 transfer boats, 3 freight line boats, 16 barges, 2 wrecking boats, 1 dredging machine, and many private boats. (Collection of the Minisink Valley Historical Society.)

This *c.* 1890s photograph of the canal shows Wurtsboro and a neighboring farm. The canal complimented the scenery in many places and added to the natural beauty of an already tranquil setting. (Robbie Smith.)

Boatyards lay silent
Locks untended,
Captains now home
The D & H is closed.

Basins are empty
Drivers grow old,
A young girl dreams of tomorrow
While standing in the memories of a past.
(Robbie Smith; poem by Matthew M. Osterberg.)

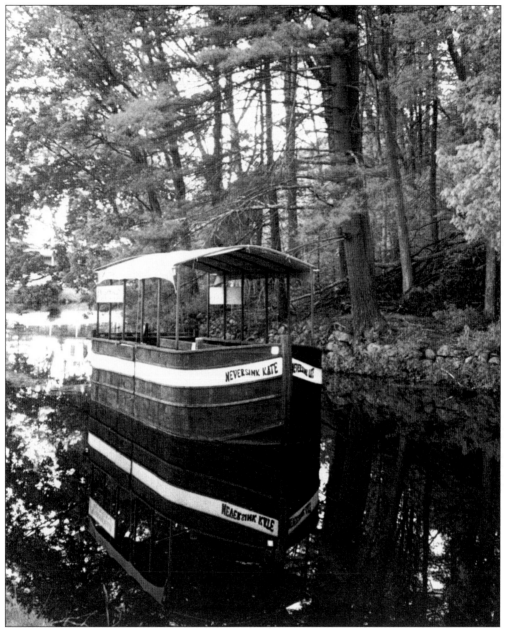

Fortunately, much of the Delaware and Hudson Canal can be seen today in many sections of the region. There is a resurgence of interest in the canal and gravity railroad, encouraging many groups to preserve and communicate the history of the Delaware and Hudson. In Cuddebackville, at the Neversink Valley Area Museum, the canal boat *Neversink Kate* floats in a preserved section of the canal. This area has a great towpath walk along the original canal with a preserved boat basin. Located in High Falls, New York, is the D & H Canal Museum and Five Locks Walk. Here, visitors have the opportunity to see the remnants of some of the many locks that were located on this section of the canal. A visit to both of these museums and others in the region can help us understand how influential the Delaware and Hudson Canal and Gravity Railroad were to the development of this entire region. (Matthew Osterberg.)

RESOURCES

This book is only a primer—to be used to spark the reader's interest in the Delaware and Hudson Canal through photographs. The books and sites listed below are resources for the reader to further his or her understanding of the Delaware and Hudson Canal.

Books

LeRoy, Edwin. *The Delaware and Hudson Canal: A History*. Honesdale, Pennsylvania: Wayne County Historical Society, 1950.

Lowenthal, Larry. *From the Coalfields to the Hudson: A History of the Delaware and Hudson Canal*. Fleischmanns, New York: Purple Mountain Press, 1997.

Lyon, J.B. *A Century of Progress: History of the Delaware and Hudson Company 1823–1923*. Albany, New York: The Delaware and Hudson Company, 1925.

Sanderson, Dorothy. *The Delaware and Hudson Canalway: Carrying Coals to Rondout*. New York: Rondout Valley Publishing Company, 1974.

Vogel, Robert M. *Roebling's Delaware and Hudson Canal Aqueducts*. Smithsonian Institution Press: 1971.

Wakefield, Manville B. *Coal Boats to Tidewater: The Story of the Delaware and Hudson Canal*. Grahamsville, New York: Wakefair Press, 1971.

Museums

Carbondale Historical Society and Museum, Carbondale, PA. (570) 282-0385
Century House Historical Society, Rosendale, NY. www.centuryhouse.org
D & H Canal Historical Society and Museum, High Falls, NY. www.canalmuseum.org
Ellenville Public Library and Museum, Ellenville, NY. (845) 647-5530
Hudson River Maritime Museum, Kingston, NY. www.ulster.net/~hrmm
Lackawanna Coal Mine Tour, Scranton, PA. (570)963-MINE
Minisink Valley Historical Society, Port Jervis, NY. www.minisink.org
National Canal Museum, Easton, PA. www.canals.org
Neversink Valley Area Museum, Cuddebackville, NY. www.neversinkmuseum.org
NPS Upper Delaware Scenic and Recreational River. www.nps.gov/upde
PA Anthracite Heritage Museum, Scranton, PA. (570) 963-4804
Steamtown National Historic Site, Scranton, PA. www.nps.gov/stea
Stourbridge Line Rail Excursion. www.waynecountycc.com
Sullivan County Historical Society, Hurleyville, NY. (845) 434-8044
Waymart Area Historical Society, Waymart, PA. (570) 488-6750
Wayne County Historical Society and Museum, Honesdale, PA. www.waynehistorypa.org

Historic Sites

Accord, NY—Three-mile trail between Accord and Kerhonkson.
Cuddebackville, NY—One-mile walk along the canal.
D & H Towpath Trails—Many sections of towpath, where mules once walked pulling canal boats, are now public recreational trails for you and your family to visit.
Ellenville, NY—Two miles of trail along Rondout Creek.
High Falls, NY—The Five Locks Walk with canal-era buildings.
Mamakating, NY—Four-and-a-half-mile trail in Sullivan County's D & H Canal Linear Park.
Minisink Ford, NY—One mile of trail near the Roebling Delaware Aqueduct.
Port Jervis, NY—Two miles of trail.
Wurtsboro, NY—One mile of trail planned for a 2003 opening.